NGORONGORO

CONSERVATION AREA

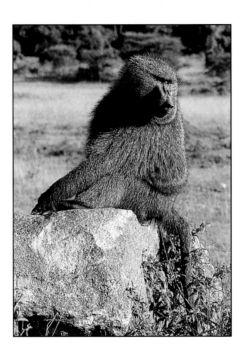

CHRIS AND TILDE STUART

STRUIK

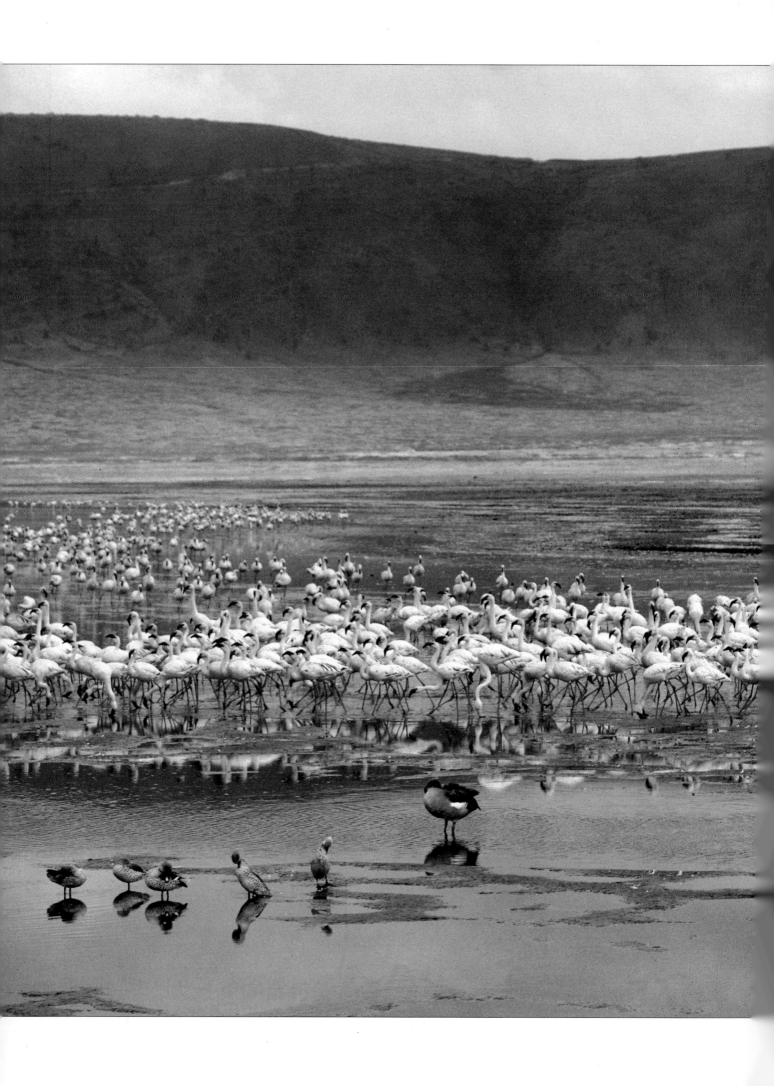

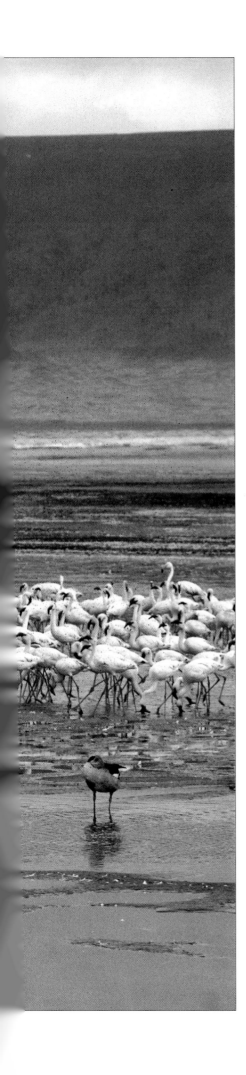

CONTENTS

THE ORIGINS OF NGORONGORO

Located within the crater highlands of northern Tanzania, the Ngorongoro Conservation Area forms part of what is known as the Serengeti-Ngorongoro-Masai Mara ecosystem. Its eastern boundary is formed by the western wall of the Great Rift Valley while its western boundary adjoins the world-famous Serengeti National Park. To the east lie Mount Kilimanjaro, Africa's highest mountain, and Mount Meru, and to the west Lake Victoria.

Geologically speaking, the landscapes of the Ngorongoro Conservation Area are a combination of both ancient and modern geological processes. The Ol Doinyo Gol mountains and the gneiss and granite outcrops scattered across the Serengeti Plain originated several hundred million years ago. Some 20 million years ago the eastern side of Africa started to crack and rift, causing the land between the rifts to subside. This resulted in the earth's crust gradually thinning and softening, allowing molten materials to thrust to the surface and form lava beds and, later, volcanoes. Within the Ngorongoro area the oldest volcanoes – Lemagrut, Sadiman, Oldeani, Ngorongoro, Olmoti, Sirua, Lolmalasin and Empakaai – were formed along the Eyasi Rift, which now forms the towering cliffs at Lake Eyasi. In the north the rift separates the Ol Doinyo Gol mountains from the Salei Plains, but much of the early rift is now obscured by lava.

It is believed that Ngorongoro once rivalled Kilimanjaro in size. The lava that filled the volcano formed a solid 'lid' which subsequently collapsed when the molten rock subsided, forming the caldera that we see today. Both Olmoti and Empakaai collapsed in a similar manner but are not as immense as Ngorongoro. Two volcanoes of more recent origin, Kerimasi and Ol Doinyo Lengai, were formed along the Gregory Rift and lie to the northeast of the Empakaai caldera. Ol Doinyo Lengai, the Maasai's 'mountain of God', is still active – its most recent eruption took place in 1983.

The vast quantities of ash produced by the volcanoes have had two principal benefits: fertile soils for crop production outside the Ngorongoro Conservation Area and the maintenance of the rich savanna grasslands that support the largest ungulate herds in the world. A third and invaluable benefit has been the preservation of an important fossil treasure-trove that has enabled archaeologists and palaeontologists alike to develop a better understanding of the origins of modern man and the creatures that inhabited this part of the world, particularly at Olduvai Gorge and Laetoli.

By two million years ago much of the landscape of the Ngorongoro Conservation Area had been formed but ongoing erosion and deposition continue to shape the earth's surface.

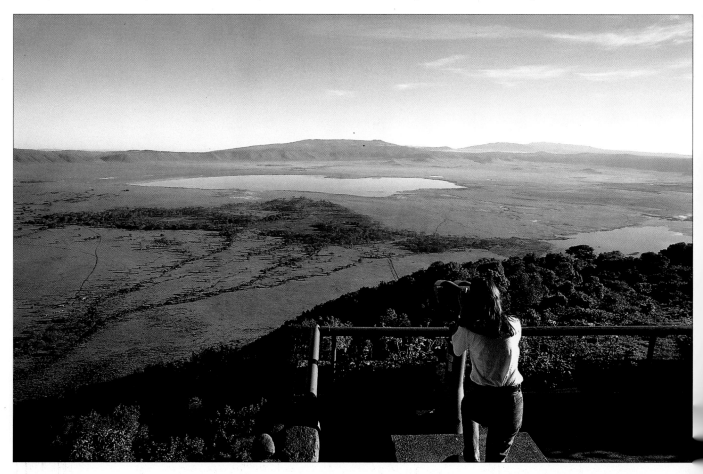

ABOVE: *The lodges located on the rim of the Ngorongoro Crater afford breathtaking views of the floor of the caldera.*

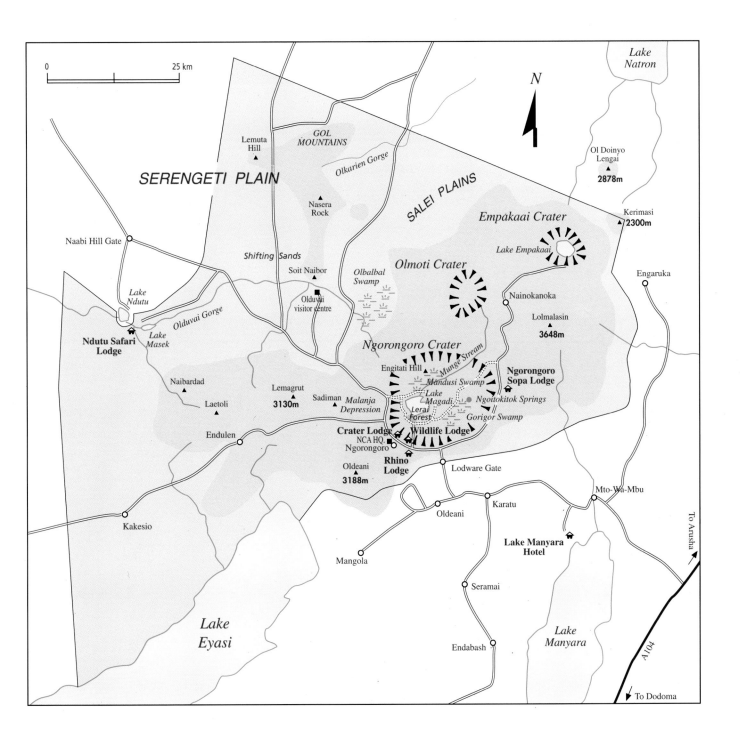

MAP OF THE NGORONGORO CONSERVATION AREA

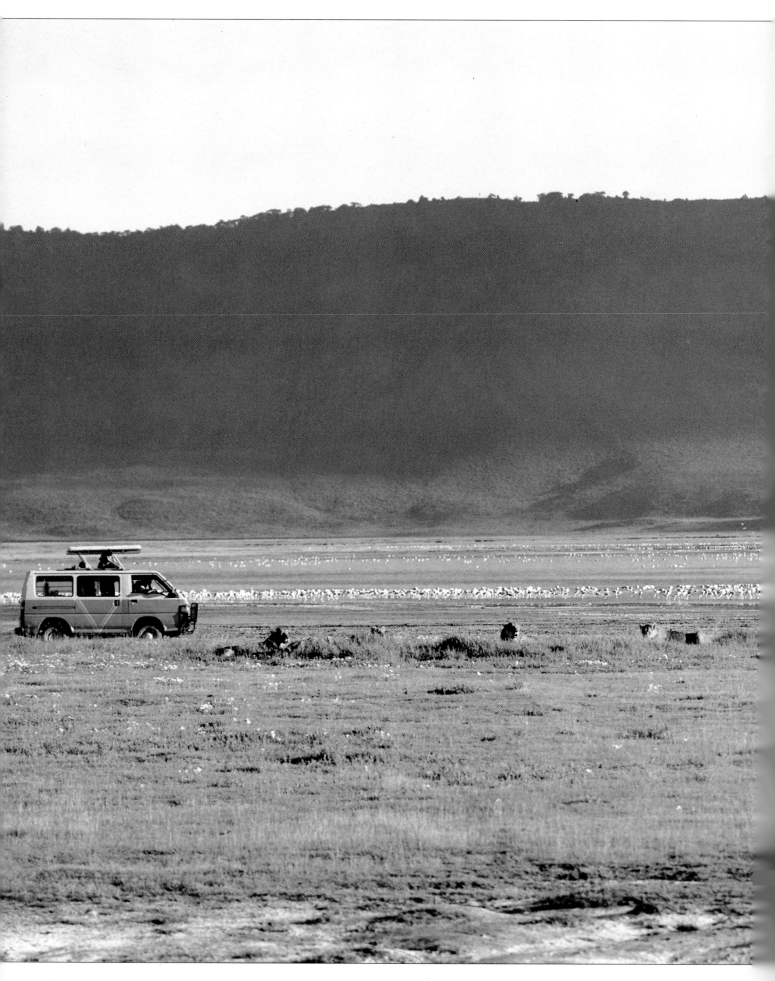

NGORONGORO CONSERVATION AREA
Nature's Balancing Act

One of the world's most impressive wildife sanctuaries, the Ngorongoro Conservation Area is a delicate experiment in balancing the needs of wildlife, Maasai pastoralists and tourism. Some of the world's greatest wildlife spectacles can be viewed here.

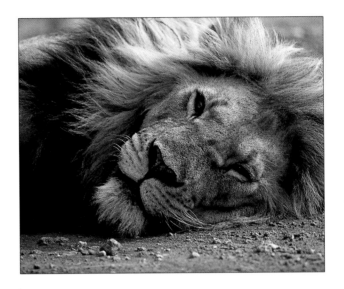

The Ngorongoro Conservation Area covers some 8 280 square kilometres, encompassing great sweeps of open grassy plains, savanna woodlands, mountains, volcanic craters, forests, rivers, lakes and swamps. The southern and eastern slopes of the highlands receive high rainfall, but the western plains lie in the mountains' rainshadow and receive less precipitation.

The approach from Arusha, the tourist capital of Tanzania, takes the visitor to the village of Mto-Wa-Mbu, 'river of the mosquito'. The road rises steeply to the Mbulu Plateau and on through the densely populated agricultural areas of Karatu and Oldeani, with their rich volcanic soils and abundant water. The cultivated land stops abruptly at the Lodware entrance gate and gives way to magnificent montane forest. After the steep climb the visitor emerges at the edge of the Ngorongoro Crater, and catches the first glimpse of one of the world's most famous and impressive wildlife sanctuaries. Within the crater are the sweeping grass plains that are home for part of the year to a vast number of game animals, some of which are participants in the greatest mass migration of large mammals in Africa. The more adventurous traveller may wish to visit the Olmoti and Empakaai craters to the northeast, and the Gol mountains.

Unlike many of Africa's conservation areas, the Ngorongoro Conservation Area Authority is attempting to manage a complex mix of wildlife, vegetation, Maasai pastoralists and their stock, as well as tourists, water catchment areas and other resources. In some ways this is succeeding. However, ever-growing numbers of indigenous people and their livestock, largely unfettered tourism and pressures around the preserve's boundaries will result in increasing difficulties for those involved with its management.

ABOVE: *The opportunity of seeing lion is one of the principal attractions for the thousands of tourists that visit the Ngorongoro Conservation Area each year.*
OPPOSITE: *The level of the soda lake, Magadi, varies according to the season.*

Ngorongoro has revealed a wealth of fossils that have given man a greater understanding of our ancestral beginnings. Some three and a half million years ago our ancient human ancestors walked across a rain-dampened volcanic ash deposit in the western area, now known as Laetoli. Tracks were also left by other creatures, including guineafowl, giraffe and a three-toed horse (*Hipparion*). Shortly afterwards the tracks were covered by a fresh layer of ash, preserving them until their discovery in 1978.

Approximately halfway between the Ngorongoro Crater and Serengeti lies one of Africa's, and indeed the world's, most important sources of fossil animal and hominid remains. Olduvai (more correctly Oldupai) Gorge is the Maasai name for the wild sisal plant (*Sansevieria ehrenbergiana*) that grows in the area. In the gorge successive lava flows, ash deposits and mud layers preserved one of the most important fossil deposits known on the African continent.

The crustal movements, faulting and volcanic actions that took place as recently as 30 000 years ago resulted in Olduvai being deeply incised. The flow of water through the gorge continued to eat the rock away, revealing a sequence of evolutionary events, from ancient lava deposits to the 'Naisiusiu' bed laid down over the last few thousand years. It is by studying these layers that archaeologists, most notably the Leakey family, have been able to trace almost two million years of human development. In the deepest layers, lying upon the thick basaltic

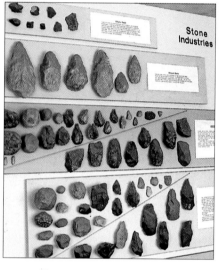

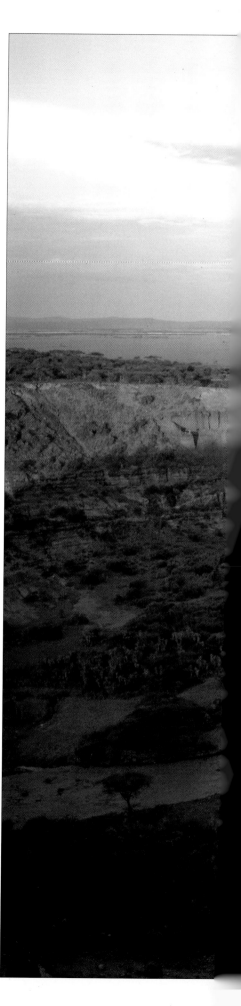

RIGHT: *For much of the year the bed of the Olduvai Gorge is dry but occasional heavy storms cause the Munge Stream to flow.*

LEFT: *The Olduvai Gorge and environs have been occupied by man and his ancestors for 35 000 centuries; and this prehistory is documented at the museum in the visitors' centre.*

BELOW: *The semi-arid nature of the Olduvai Gorge is an ideal habitat for the large lizard species, including the agama group. These conspicuous lizards frequently live in 'harem' groups with a single adult male holding sway over several, more dull-coloured females.*

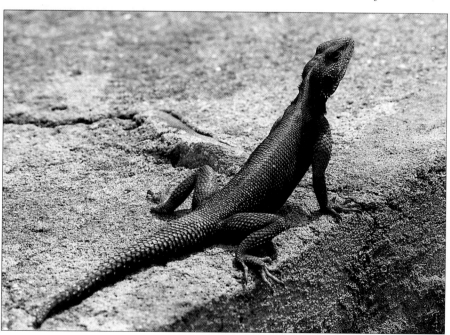

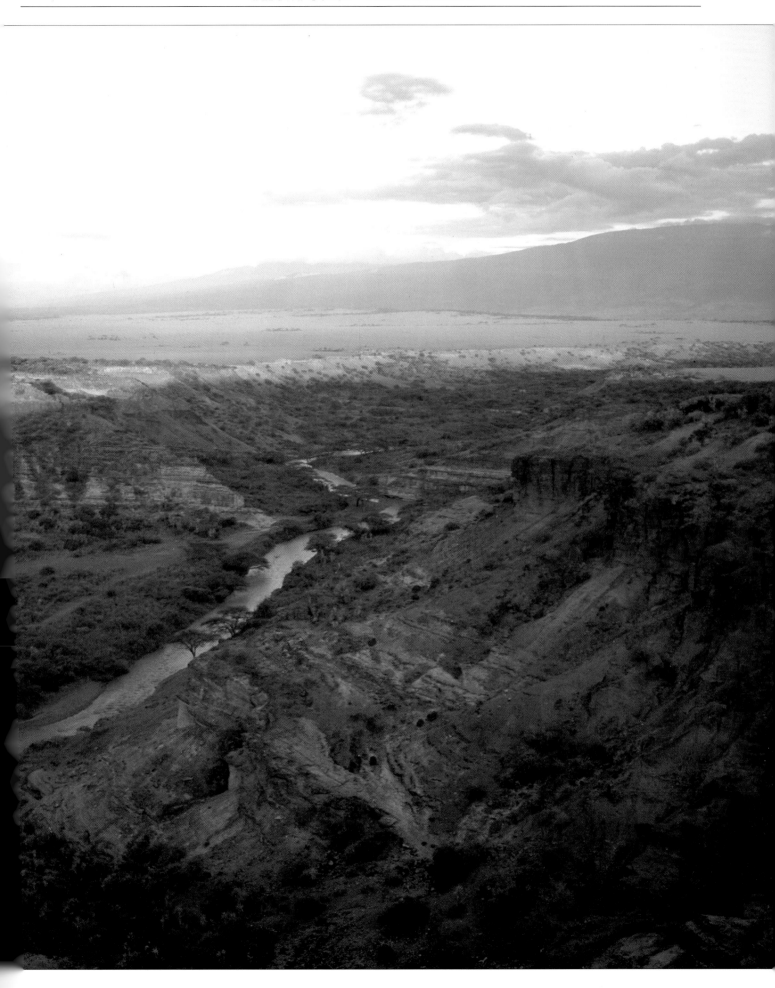

Shifting Sands and Plain Lakes

There are a number of locations on the northern plains where low dunes have been formed from volcanic ash thrown out by Ol Doinyo Lengai **(below)**. Shifting Sands is one of the dunes that has become well known as it lies close to the Olduvai Gorge Visitor Centre. This isolated black barchan dune is approximately nine metres high, and 100 metres around the curve. The wind continually blows the grains up its windward slope, where they tumble over onto the leeward slope, causing the dune to move an average of 17 metres each year.

Both Lake Ndutu and Lake Masek lie in the valley that, to the east, forms the Olduvai Gorge. Lake Ndutu (also known as Lake Lagarja) is located just inside the Serengeti National Park, and Lake Masek just within the Ngorongoro Conservation Area. Both lakes are alkaline and attract a great variety of birds, including Superb Starlings and Woodland Kingfishers, particularly during the rainy season when many species of migrant birds arrive in the area. The vast herds of game, most notably the wildebeest, are only present during the rains, but during the dry season it is still possible to see a great diversity of resident mammals. Giraffe are common, favouring the abundant acacia woodland, and there are also Kirk's dik-dik, steenbok, impala, Coke's hartebeest and elephant, while predators are represented by, among others, lion, leopard, occasionally cheetah, spotted hyena, bat-eared fox and serval. The secretive striped hyena, which occurs throughout the Ngorongoro-Serengeti system, may be sighted here but unlike its more social cousin, the spotted hyena, is solitary.

Jackal are also present close to the lakes, as they are throughout much of the area. The most frequently seen and the most common of the three species of jackal is the black-backed jackal. These medium-sized carnivores have a number of interesting behavioural traits, such as mating for life, which is unusual for a mammal. Young from the previous season's litter will often remain to raise the young from the following year. The 'helpers' assist the mother in feeding the pups, and also undertake guard duty should both parents go hunting. This has the benefit of ensuring that a greater number of young animals survive.

gorge bed, the remains of *Australopithecus robustus* and *Homo habilis* were discovered. The large, heavily built *Australopithecus* disappears from the fossil record some 1.2 million years ago, but the smaller, larger brained *Homo habilis* ('handy man') is believed to have evolved into the more advanced *Homo erectus* ('upright man'). In the upper bed, dated at some 17 000 years before the present time, the remains of modern man (*Homo sapiens*) were discovered. Archaeologists have also been able to trace the development, improvement and refinement of the various stone tools used, as well as the climate at different times and its influence on the vegetation and animal life.

We know that up to 1.5 million years ago Lake Olduvai and its surrounds were populated by a variety of creatures that are now extinct, including a sabre-toothed cat, two species of elephant and a giant giraffe-like browser. Some creatures, such as hippo, crocodile and several bird and fish species, have remained unchanged to this day.

In the small museum of the visitors' centre at the Olduvai Gorge, various displays show the evolution of man's ancestors, the development and refinement of his tools, and the animals that shared his environment during the different periods. Guides are available to take visitors into the gorge.

BELOW: *The Red and Yellow Barbet is one of at least nine barbet species that occur in the highlands and savanna woodlands of northwestern Tanzania. This colourful bird favours dry areas covered in acacia woodland.*

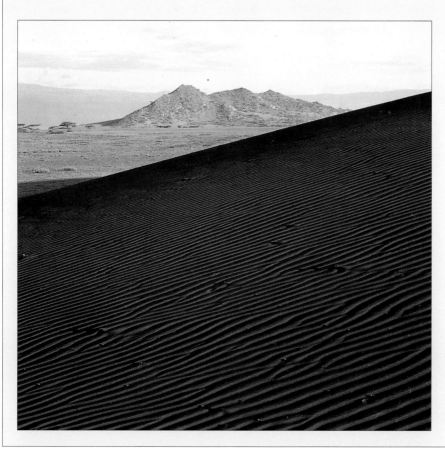

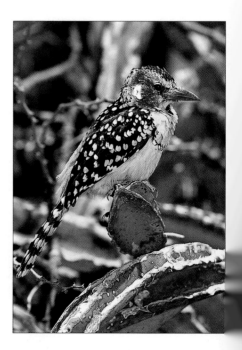

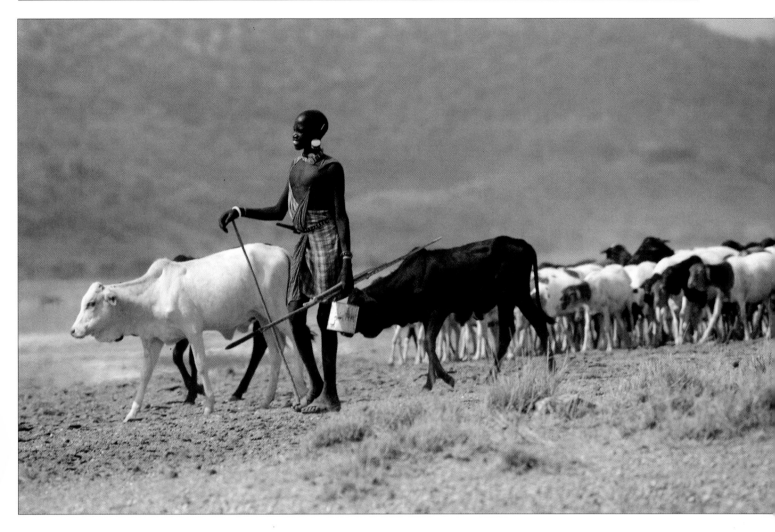

The discovery of the fossil remains in Olduvai Gorge have allowed archaeologists to calculate that the first pastoralists and their cattle entered the region now known as the Ngorongoro Conservation Area approximately 10 000 years ago. They became known as the 'Stone Bowl' people in recognition of the containers they hewed out of the volcanic rock, but they seem to have disappeared about 1 000 years ago. The Mbulu people, who still live between the Ngorongoro highlands and Lake Manyara, arrived during the last 2 000 years and are both pastoralists and cultivators. The Datoga, a warrior tribe that kept cattle, entered the area as recently as 300 years ago. They were eventually driven out of these rich grazing grounds by the Maasai, the tribe that dominates the Ngorongoro grasslands today. The tall Maasai belong to the Nilo-Hamitic group of peoples. They freely roam Ngorongoro, beyond into Kenya, and eastwards into the Great Rift Valley and the so-called Maasai Steppe of Tanzania. As the Maasai are not generally meat-eaters, they live in relative harmony with the wildlife herds. In the Ngorongoro Crater, the Maasai descend the

ABOVE: *The Maasai are still allowed to descend to the Ngorongoro Crater floor to water their cattle and goats, but only at Seneto Springs.*
RIGHT: *Most Maasai women wear elaborate ear ornaments.*

steep crater walls to water their cattle, sheep and goats at the Seneto Springs, which lie at the foot of the descent road. It is not unusual to see cattle and several antelope species grazing in close proximity to one another.

In the early decades of this century Ngorongoro was occupied and hunted by European colonials. In 1951 the Serengeti National Park, which incorporated much of the present conservation area, was proclaimed. However, in 1956 the Maasai and the wildlife department authorities clashed over utilization rights and Serengeti and Ngorongoro were split, with the former retaining national park status. All pastoralists were moved into the present Ngorongoro Conservation Area. With independence in 1961 it was decided that Ngorongoro was to be managed for the benefit of its natural riches and as a haven for the Maasai.

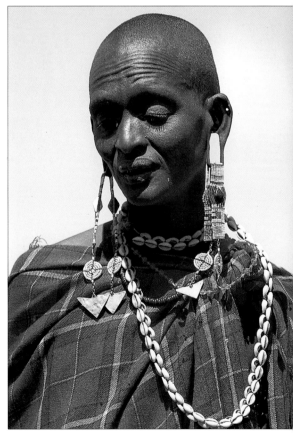

PREDATORS — *Tooth and Claw*

The predatory mammals occurring in the Ngorongoro Conservation Area, and more particularly in the Ngorongoro Crater, have been intensively studied by scientists. **Lion**, largest of the African cats, are present throughout the highlands and on the savanna plains. They occur in higher densities within the Ngorongoro Crater than elsewhere in the conservation area. Although the exact numbers of lion within the Serengeti-Ngorongoro ecosystem are not actually known, there are estimated to be between 2 000 and 3 000 individuals, one of Africa's largest single populations. The Ngorongoro Crater can lay claim to having the densest lion population anywhere, with numbers fluctuating between as many as 80 and 100 individuals.

Lion live in complex social groupings, popularly known as prides. Each pride includes a relatively stable 'core' of related females, their dependent cubs from different litters as well as a single adult male, or more commonly a coalition of two or more males. When reaching sexual maturity, female offspring may remain with the birth pride, or form their own pride as a group. Male offspring, however, usually form a coalition and leave the birth pride until they are old enough to take over a pride themselves. The competition between single males and coalitions of lions for control over prides is extremely intense. Such takeover attempts only take place once the usurpers are more than four years old. When invading males succeed in driving away a group of pride males, the new animals usually kill any cubs that are present, thus ensuring that it is their genes and not those of the vanquished lions that will be perpetuated.

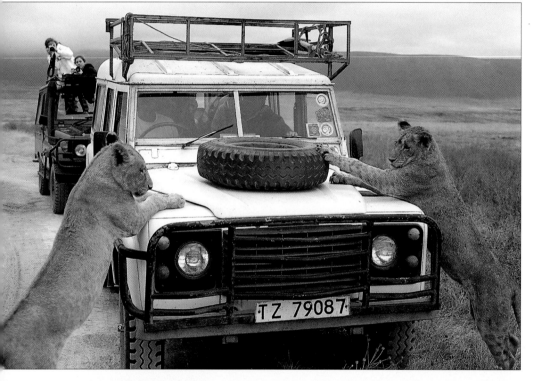

LEFT: *Lion in the Ngorongoro Crater show little fear of man but visitors should always remember that these are potentially dangerous wild animals and should be treated as such.*
OPPOSITE: *With the vast number of prey animals available, the lions living in the crater do not have to move far to hunt. Lions occurring elsewhere in the conservation area cover greater distances.*
BELOW: *Leopard occur throughout the Ngorongoro Conservation Area, although they seldom wander far from cover. Most hunting takes place at night, or during the cooler early morning and late afternoon hours. Unlike the social lion, they are solitary predators.*

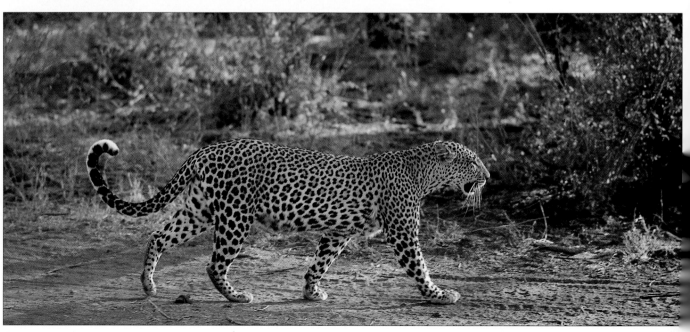

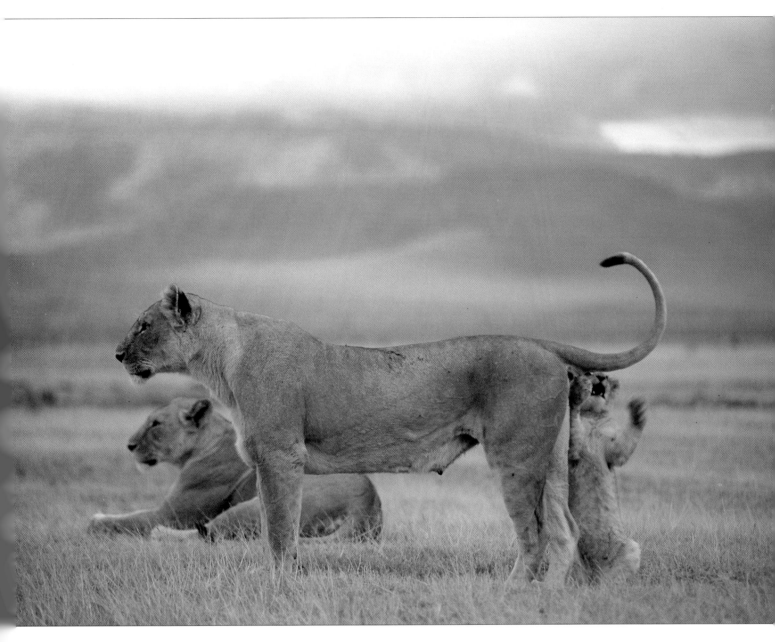

Within the normal pride situation the lionesses undertake most of the hunting (it is not as though the males are less successful at hunting, as male coalitions without prides have no problem obtaining sufficient food), and the adult males generally feed first. Within the Ngorongoro Conservation Area lions take a wide range of prey species, but particularly wildebeest, plains zebra and Thomson's gazelle. Apart from actively hunting their own prey, they frequently chase other predators from their kills, and often feed on the carcasses of other animals.

Leopard are far more elusive than lion, being largely nocturnal and solitary animals. They are present, however, in the forests of the crater rim and sparse elsewhere in the conservation area. The diet of the leopards within the conservation area overlaps little with that of the lion or the spotted hyena, although it does include the young of some of the larger antelope. Leopard concentrate mostly on the smaller species of antelope, as well as on a range of rodents, hyrax and birds. Although they are often believed to be major predators of baboons, this is in fact not so and they will only occasionally take a primate. Unlike the other large predators, leopard have the ability to carry bigger prey into trees out of reach of their competitors.

Cheetah are only rarely glimpsed and even these are invariably individuals passing through the Ngorongoro Conservation Area on their way to the Serengeti Plain. Nevertheless, because of the more open terrain which they favour, they are sometimes seen. Sightings of cheetah on the crater floor, however, are unusual. Solitary cheetah may be sighted but pairs, groups of males and small family parties are also not uncommon.

Being the most slender of the big cats, cheetah are not well adapted to competing with the larger predators such as lion and this has a limiting effect on their population size. What they lack in strength, however, they make up for in speed. Within the conservation area their principal prey is the small Thomson's gazelle, which, at the end of the chase, is usually so weakened that it cannot put up much of a fight. Female cheetah occurring on the plains in northwestern Tanzania have been shown to occupy very large home-ranges, averaging 800 square kilometres. Males defend only small territories of about 40 square kilometres, although ranges are probably larger. A study that was undertaken on the Serengeti Plain found that cheetah-cub mortality may even be as high as 98 per cent, a sobering thought considering it is Africa's most threatened large cat.

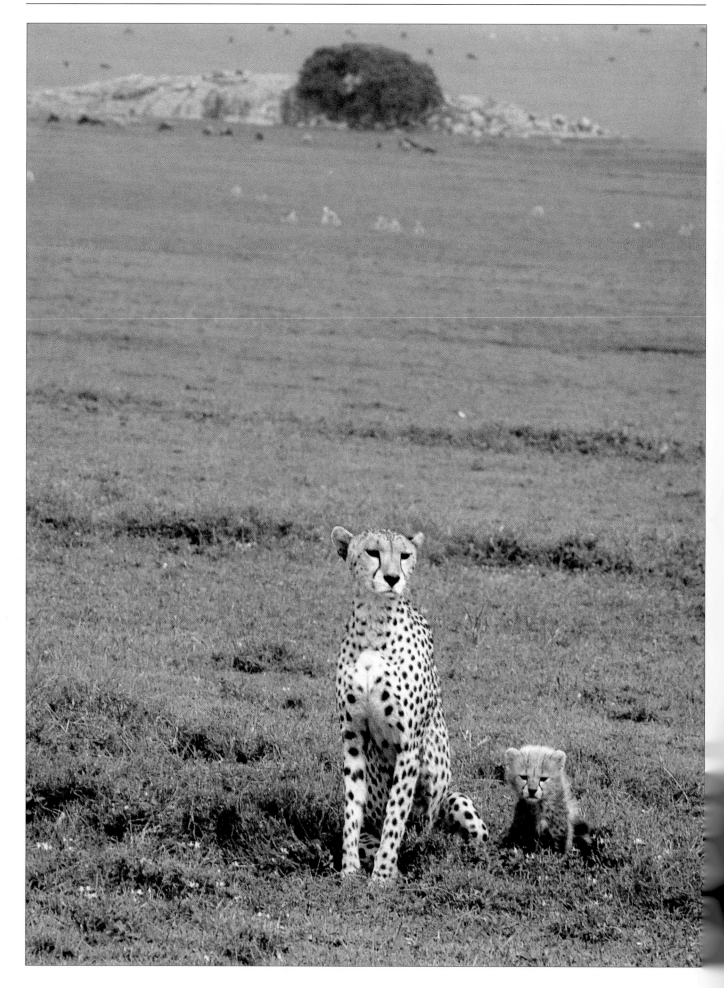

Spotted hyena are not skulking scavengers as they are sometimes portrayed but skilled pack hunters, quite capable of overpowering and pulling down plains zebra and wildebeest. Female hyenas form the social nucleus of a clan, with a female leading the group in territorial defence and many social interactions. Although much of their hunting takes place at night, particularly in the hot summer months, hyena are frequently observed resting up in the shade, or at waterholes where they are not averse to lying in the cooling water and mud.

It has been estimated that there are more than 400 adult and subadult spotted hyenas present in the Ngorongoro Crater, in several territory-defending clans. Owing to the great abundance and permanence of their food, these crater hyena have little need for large territories. The clans outside the crater occupy more extensive ranges and move greater distances when hunting, as the herds of the Serengeti Plain are to a large extent migratory. The smaller striped hyena is only found on the dry plains.

African wild dogs, or hunting dogs, are highly social animals that live in stable packs and undertake carefully coordinated hunts. Now extremely rare, it is the lucky visitor who catches a glimpse of Africa's most endangered large carnivore. The members of the pack hunt in a cooperative manner, preying mainly on wildebeest and gazelles. The hunters slowly move towards the selected prey animal, gradually increasing their speed as the targeted animal starts to run. These dogs rarely deviate from their choice and may follow the unfortunate animal for several kilometres. This predator is one of the most efficient hunters of the plains, contrary to common belief it does not kill wantonly rather for the needs of the pack only.

OPPOSITE: *Cheetah are uncommon within the conservation area.*
BOTTOM: *Wild dogs feed young pups at the den by regurgitating meat.*
BELOW LEFT: *Lion cubs may suckle from any lactating lioness in a pride.*
BELOW: *Spotted hyena are both efficient pack hunters and scavengers.*

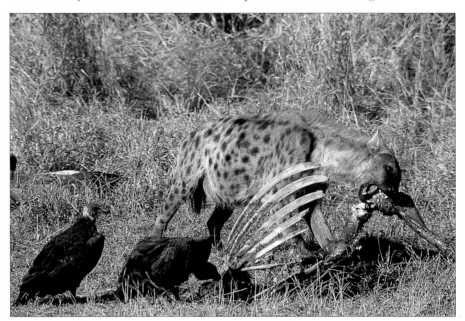

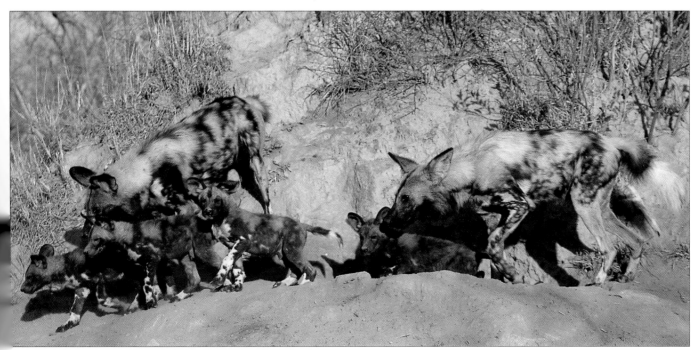

Great herds of wildebeest share the grasslands with many other ungulate species such as plains zebra, Thomson's gazelle, Grant's gazelle, topi and kongoni (Coke's hartebeest). The warthog is resident throughout the Ngorongoro Conservation Area, with relatively high densities on the crater floor.

Plains zebra are usually found in association with the great wildebeest 'tides'. The typical zebra herd consists of one stallion, several mares and their accompanying foals. Although the mares may drop foals at any time of the year, most are born during the rainy season (from November to May) when there is an abundance of grazing. Both the wildebeest and the plains zebra are crucial to the diet of the lion and the spotted hyena.

Five subspecies of the plains zebra are recognized by scientists but only **Grant's zebra** occurs in northern Tanzania and adjacent Kenya. Grant's zebra are by far the most numerous of the subspecies with probably more than 500 000 occurring throughout their range. A significant percentage is located in Ngorongoro and adjacent conservation areas. Unlike the species found further to the south, Grant's zebra do not have the so-called 'shadow-stripe' on the white stripes, but only clear white and black striping.

Masai giraffe, also known as Kenyan giraffe, do not occur within the Ngorongoro Crater as there is a lack of suitable browse trees. However, on the plains and dry wooded hills to the west they are common and can often be seen striding across the open plains between feeding sites. As they can exceed a height of five metres, they stand out from the relatively short trees on which they feed over much of this area.

The dainty **Thomson's gazelle**, weighing up to 28 kilograms, is the most endearing of the plains antelope. Affectionately known as 'Tommies', these attractive gazelles form small herds of up to 60 animals, but on the short-grass plains these herds may amalgamate and many thousands may be seen feeding together. Thomson's gazelles can be differentiated from the larger Grant's gazelles by their distinct black lateral stripes and their constantly flicking black tails.

OPPOSITE BOTTOM: *Kongoni, or Coke's hartebeest, may be seen in isolated herds, or mingling with wildebeest, gazelles and zebra on the open grassed plains.*
LEFT: *Masai giraffe are a common sight in the western sector of Ngorongoro.*
BELOW: *The male Grant's gazelle carries the longest horns of any of the African gazelle species.*

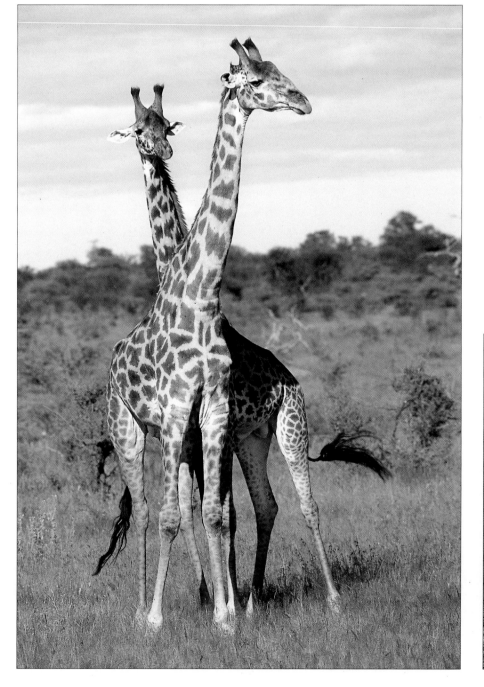

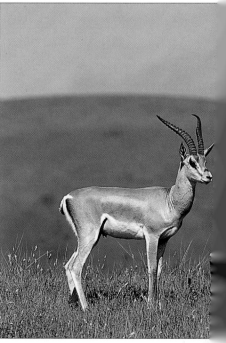

The vast expanses of open country in the Ngorongoro Conservation Area and adjacent areas of Serengeti allow for easy viewing of the many herbivores and their predators. Each prey species has a 'flight-distance' – the distance they keep between themselves and the carnivores they perceive as a threat. Thomson's gazelle will flee from a pack of hunting dogs when they draw closer than one kilometre, whereas cheetah can usually approach to within 500 metres before putting these gazelles to flight. Lion at a distance exceeding 300 metres are generally ignored and black-backed jackal may approach to between fifty and five metres. This early warning system ensures that these small antelope do not waste unnecessary energy in running away when the threat is minimal.

When very young, gazelle fawns are most vulnerable to predation and yet it is not unusual for a lion, leopard or spotted hyena to pass within a couple of metres of a fawn without detecting its presence. This is because the superbly camouflaged fawn lies down and freezes at the first indication of the approach of a predator. Another factor is that the fawn gives off virtually no body scent.

The 50- to 80-kilogram **Grant's gazelle** live in herds of up to 30 individuals, but never gather in the large concentrations formed by the Thomson's. The latter are predominantly grazers, while the Grant's are true mixed feeders. Grant's gazelle are also less subject to local movement than are their smaller relatives. While Thomson's gazelle undertake limited migrations in search of new pastures and drinking water, Grant's

The Migration

When the rains arrive in January and February, vast herds of wildebeest and plains zebra, as well as Thomson's gazelle, gather on the plains surrounding Lake Ndutu and around the Moru and Gol hills. Here they graze on the grasses that have flourished during the rains – drop seed (*Sporobolus ioclados* and *marginatus*), finger grass (*Digitaria macroblephara*), mat grass (*Andropogon greenwayi*) and the love grasses (*Eragrostis* spp.). It is also at this time that calving takes place **(below)**. The Maasai stay away from the plains at this time to avoid their cattle being infected by a disease carried by the newborn wildebeest calves.

At the end of May the plains dry up, the grasses die back and the herds move on, crossing lakes Ndutu and Masek in their relentless search for fresh grazing. They sweep northwards across the Serengeti Plain, through the woodlands to the western corridor. By August they have reached Masai Mara. When the grazing in the Mara has been exhausted (around October), the herds set out on the last stretch of the migratory path – southwards back to the plains where the calves are dropped. With the return of the rains the cycle is repeated.

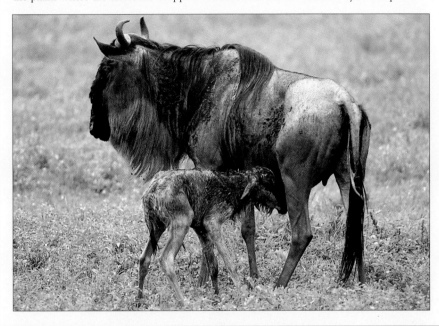

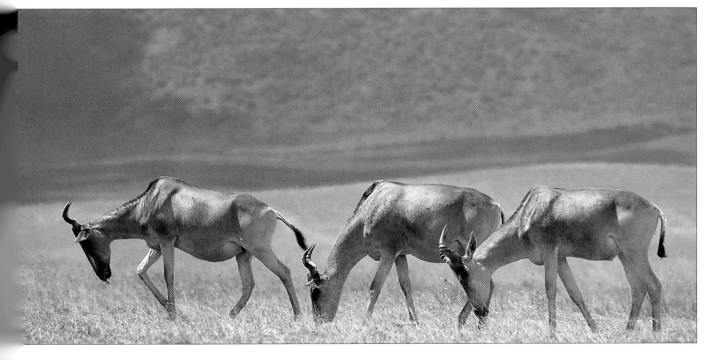

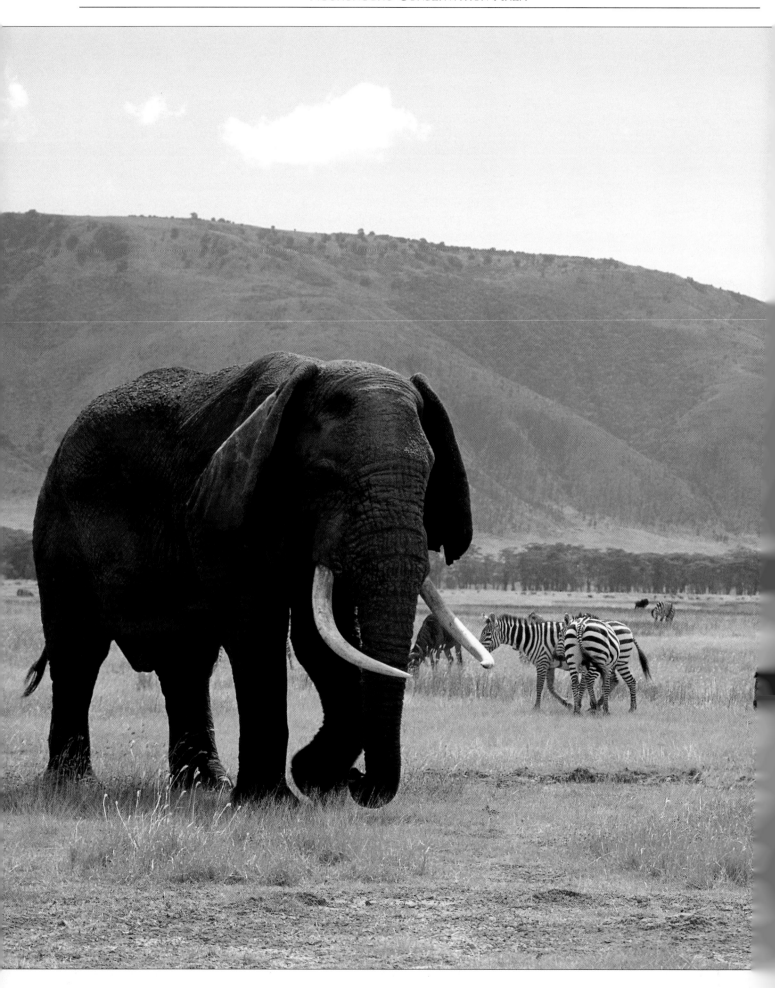

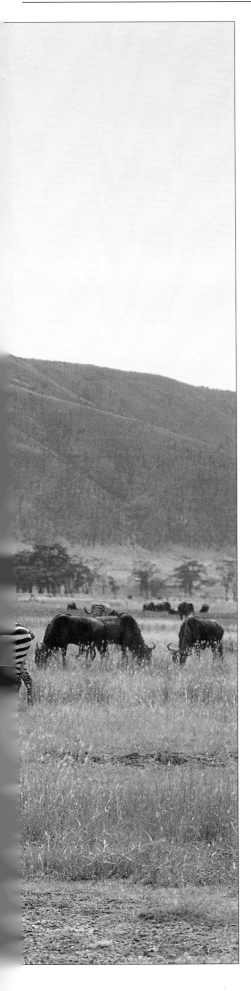

gazelle are able to remain approximately within the same areas throughout the year as they have a more varied diet and do not need to have access to surface water. The numbers of Thomson's gazelles, probably more than 500 000 within the Serengeti-Ngorongoro ecosystem, have increased in tandem with the rise in the wildebeest population, as the gazelles benefit from the cropped grasses left by their larger relatives.

Apart from the considerable difference in size of the two gazelle species in Ngorongoro, they also differ in their behaviour. The territorial Grant's rams virtually never come into direct conflict situations but try to drive off rivals by striking threatening postures. Thomson's gazelle males on the other hand fight for possession of their territories, although serious injury is a rare occurrence.

Kongoni (Coke's hartebeest) and **topi** are also present on the open plains. Kongoni form small herds in the Ngorongoro Crater and in the hills, and on the plains to the west. Topi, on the other hand, are absent from the crater. Both of these species may be seen with other plains game. They appear similar, but kongoni have a much lighter coloration and differently shaped horns.

Kongoni are one of several hartebeest subspecies that were once found very widely on the savannas of sub-Saharan Africa. However, hunting, competition for grazing with domestic livestock and loss of suitable habitat have resulted in large reductions in numbers. Healthy populations of kongoni still survive on the plains and grassed hill slopes of the Ngorongoro Conservation Area. Despite its somewhat ungainly appearance, this and other members of the family are considered to be the swiftest of all the antelopes.

Impala frequent woodland thickets and bushy river courses, but are absent from the crater floor. In Ngorongoro and in adjacent Serengeti, the adult rams have particularly long horns. It is not unusual to observe impala and Thomson's and Grant's gazelle feeding in close proximity to one another.

Despite the numbers and the great variety of herbivores within Ngorongoro, undue competition is avoided by the vast herds of wildebeest, plains zebra and Thomson's gazelle following traditional migration routes that prevent excessive overgrazing. If these migration routes were ever to be blocked, huge numbers of game animals would die from starvation and thirst. Although several different animals may feed on the same species of plant, excessive competition is avoided by their feeding on it at different growth stages, or in different seasons. These herbivores can be broadly divided into browsers (trees, bushes and shrubs), grazers (grass) and mixed feeders that both graze and browse. Undue competition is also avoided by the animals having different times of activity, with some species only feeding at night and others during the daylight hours.

OPPOSITE: *Only the bull elephants are to be seen on the Ngorongoro Crater floor.*
BELOW: *The dainty Thomson's gazelle continuously flicks its short dark tail.*

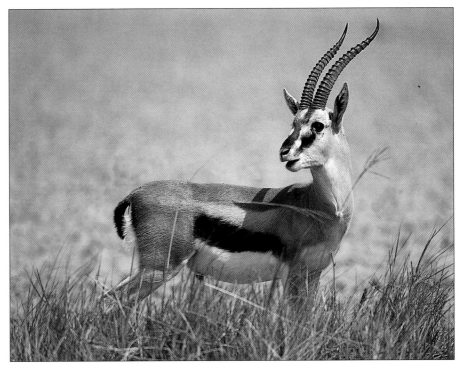

THE SMALLER CREATURES — *A Place for Everything*

In their eagerness to spot the so-called 'big five', visitors to the park often overlook the smaller creatures that have so much to interest the animal lover. Many of these animals are nocturnal and live in the forested areas, which makes them difficult to spot.

Three species of **hyrax** occur within the Ngorongoro Conservation Area: the rock, the yellow-spotted rock and the tree hyrax. The first two species occupy rocky habitats throughout the area but the third is restricted to the forests within the eastern parts of Ngorongoro. The rock dwellers are predominantly diurnal, retreating to the crevices and boulders as the sun sets. In contrast, the tree hyrax rests in trees during the daylight hours, emerging to feed as darkness falls. However, tree hyraxes often sprawl out on branches in the morning to sun themselves. The agility of all three species is remarkable but although the pads of their feet are pliant and rubbery, they show no obvious adaptations to aid climbing. Each of the species is quite vocal but the tree hyrax has evolved a bloodcurdling call: a series of croaks building up to a crescendo of screams. It can be a frightening experience for the first-time listener.

Seven species of primate occur within the conservation area: the olive baboon, vervet monkey, patas monkey, black-and-white colobus monkey, blue monkey, the thick-tailed bushbaby and the lesser bushbaby. The species most easily spotted is the **olive baboon**. It lives in extensive troops and spends much of its time in the open and in woodland savanna. The **vervet monkey**, an attractive grey-coloured primate with a black face, is also frequently seen. The monkey that is best adapted to life on the open savanna grasslands is the patas, sometimes referred to as the 'greyhound' of the primate assemblage. The troops range widely across Serengeti and are occasionally seen on the western plains of Ngorongoro. The smallest species of primate are the **bushbabies**. They occupy the woodland areas but avoid the true forest and are seldom seen because of their nocturnal habits. The call of the larger thick-tailed bushbaby is a harsh scream that is one of Africa's most frequently heard night sounds.

Two species of monkey are found only in the eastern forests – the magnificent **black-and-white colobus monkey** and the blue monkey. Probably the best location for

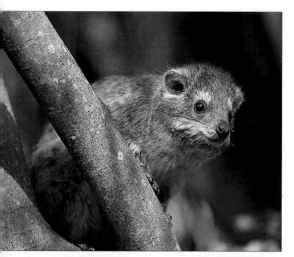

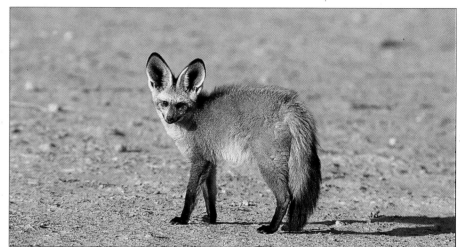

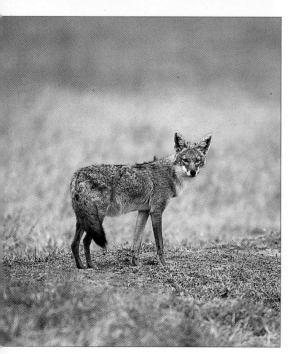

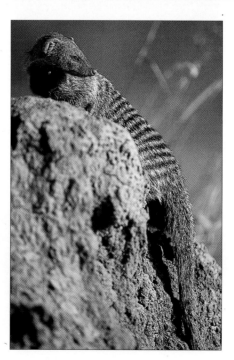

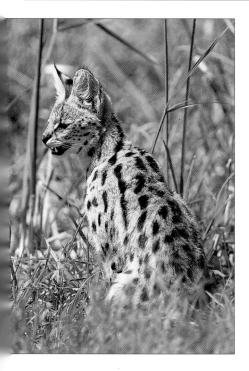

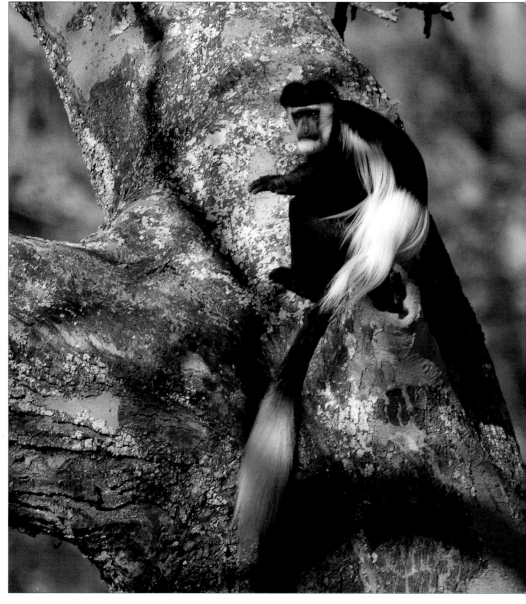

ABOVE: *The serval is found throughout Tanzania but is difficult to spot.*
OPPOSITE TOP LEFT: *The tree hyrax is restricted to the highland forests.*
OPPOSITE TOP RIGHT: *Bat-eared foxes live in small family parties.*
OPPOSITE BOTTOM LEFT: *The black-backed jackal is a resourceful animal.*
OPPOSITE BOTTOM CENTRE: *The banded mongoose is one of two mongoose species in the conservation area.*
OPPOSITE BOTTOM RIGHT: *The lesser bushbaby is a strictly nocturnal primate.*
RIGHT: *The black-and-white colobus monkey can be seen in the forest areas.*

observing them is on the ascent road from the Lodware Gate to the rim of the Ngorongoro Crater. In the early morning, the colobus monkey gives vent to a far-carrying, deep throaty croak, making troops aware of territorial boundaries. The colobus monkey is also one of the easiest of all African forest monkeys to observe as it frequently suns itself on exposed tree branches.

The **blue monkey** is a much duller species than its flamboyant cousin but nevertheless is well worth taking the time to observe. Unlike the black-and-white colobus monkey which feeds primarily on tree leaves, the blue monkey has a more varied diet that includes almost any part of the plant – fruits, leaves, flowers and buds.

There are many other smaller species that inhabit the Ngorongoro Conservation Area, such as the bat-eared fox and black-backed and golden jackals. The side-striped jackal is also present in the better watered areas of the region. These four wild canids are able to coexist with negligible competition.

The **bat-eared fox** favours the open plains and grasslands where it feeds on insects, particularly termites, and runs in small troops that usually consist of a male, female and the offspring of the most recent litter.

The **golden jackal** is also largely restricted to the flat grasslands, including those on the Ngorongoro Crater floor, particularly if there are some dense bush clumps in the vicinity. **Black-backed jackals** are much greater opportunists than their relative and range through all available habitats with the exception of the dense montane forests.

Both of these jackals have catholic diets, which include insects, carrion, fruit, berries, young Thomson's gazelles and other small antelopes. The birth of the young of black-backed and golden jackals is largely synchronized to coincide with the dropping of Thomson's gazelle fawns, providing an abundant though short-term source of food.

The range of the more scarce **side-striped jackal** is to a great extent restricted to areas of higher rainfall or permanent water such as the Mandusi Swamp. Unlike the other jackals it is almost exclusively a solitary forager.

Troops of **dwarf** and **banded mongooses** scurry around where there is some bush cover and the serval is most easily observed near the water sources, particularly within the Ngorongoro Crater itself.

The spotted **serval** haunts the grassed areas along the streams, swamps and marshes where the rats and mice that form much of its diet occur in high densities. If you are lucky enough to see serval it is well worth the time to observe how the large ears, acting like radar scanners, listen for the slightest sounds made by their rodent prey.

BIRDLIFE – *On the Wing*

Home to no less than 400 species of birds, the Ngorongoro Conservation Area enthralls ornithologists and amateur bird-watchers alike. With its range of habitats – forest, grassland and wetland – the area supports an astonishing diversity of birdlife.

Bird-watching in the highlands and forests is often more rewarding than game-watching. The Augur Buzzard, searching for prey from a high vantage point or soaring above the forests, is one of the birds visitors are most likely to see. Helmeted and Crested Guineafowls, Silverycheeked Hornbills and Hildebrandt's Francolins are also among the many different birds that can be spotted in these areas. The grassland and bush are where bird-watchers can usually see the handsome

Superb Starling, one of the most frequently photographed birds in East Africa. Other photogenic birds are the sunbirds, such as the Bronze and Tacazze Sunbirds; it is not even necessary to leave your accommodation to find these as they often hover around the bushes and flowers at the lodges.

Ascending from the Ngorongoro Crater floor, an alert visitor may be lucky enough to spot Livingstone's Turaco or the colourful Narina Trogon. More noticeable are the grassland birds of the crater floor. These include the Masai Ostrich and the Kori Bustard, Africa's largest flying bird. During the breeding season the Kori Bustard puts on a remarkable display, puffing up the feathers around its neck and head, and calling with a

loud booming sound. The beautiful Crowned Crane is another bird that puts on a captivating breeding display, involving a graceful 'pas de deux' between the male and the female. Less beautiful, but equally interesting, are the vultures, often found in the grasslands feeding from the predators' kills.

The birdlife of the Ngorongoro Conservation Area depends not only on the seasons (from November through May European migrants mingle with the resident birds) but also on the state of the water in the lakes and swamps. The variety of birds found at Lake Magadi changes according to the concentration of soda in the water and the level of the lake. Flamingos, ducks and storks are local migrants that come and go depending on the

OPPOSITE RIGHT: *Crowned Cranes may occasionally be seen on the Ngorongoro Crater floor, as well as on the plains after good rains have fallen.*
OPPOSITE TOP: *The Lilacbreasted Roller is one of five species of roller that have been recorded within Ngorongoro.*
OPPOSITE BOTTOM: *The Superb Starling truly lives up to its name.*
LEFT: *The Longtoed Lapwing, or Plover, frequents the swamp areas.*
FAR LEFT: *Both species of flamingos feed in the shallow waters of Lake Magadi.*
BOTTOM LEFT: *Africa's largest hornbill, the Ground Hornbill, feeds on a wide variety of invertebrates, small mammals and the young of ground-nesting birds.*
BELOW: *Yellowbilled Storks frequent most water sources in the conservation area but not as permanent residents.*

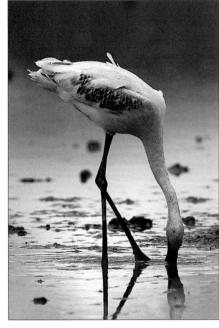

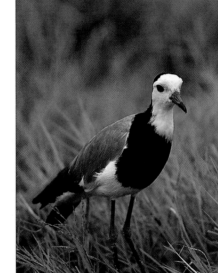

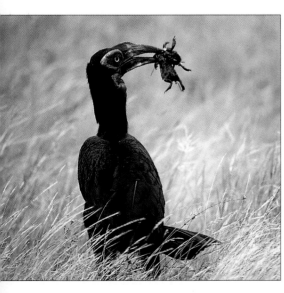

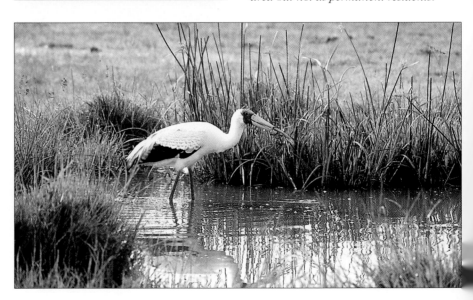

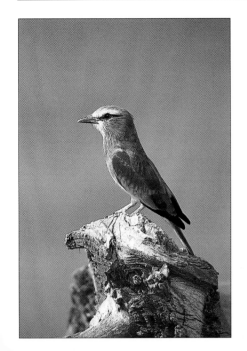

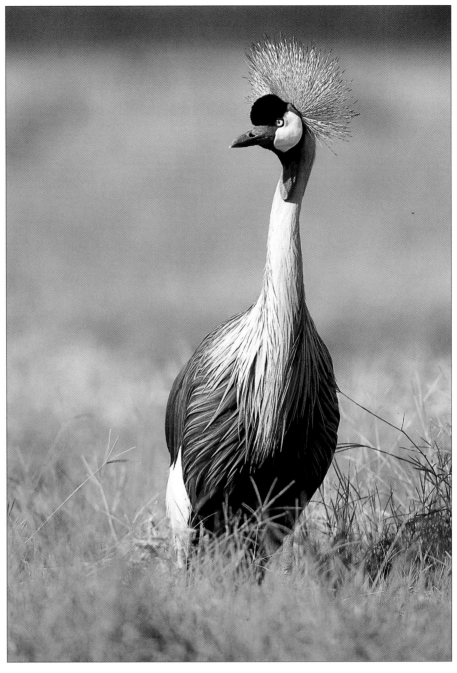

condition of the water sources. Most of the birds at Lake Magadi can be seen where the fresh water from the Mandusi Swamp enters the lake. The algae and other small organisms that flourish in the waters attract Greater and Lesser Flamingos which flock into the crater.

Although Africa's great flamingo concentrations are located principally at Lake Natron in Tanzania, and lakes Nakuru and Bogoria in Kenya, several thousand flamingos also descend to the floor of the Ngorongoro Crater. As their names indicate, one species is larger than the other species – the Greater Flamingo has a total length of between 1.4 and 1.7 metres, and an average weight of two to four kilograms while the Lesser Flamingo rarely exceeds one metre in length and has a

maximum weight of less than two kilograms. The Lesser Flamingo is usually encountered in much larger flocks than the Greater Flamingo but both mix freely together. They are able to feed together without competing as each seeks out different food – Lesser Flamingos usually feed on minute organisms in the upper water surface (blue-green algae and diatoms), while Greater Flamingos feed on the coarser material at deeper levels (brine shrimps and insect larvae). It has been estimated that a mixed flock of 1 000 Lesser Flamingos and the same number of Greater Flamingos requires almost 500 kilograms of food each day! Considering that most of their food consists of minute animals and plants, this figure is quite extraordinary.

The extensive Gorigor Swamp, with its abundance of aquatic vegetation, attracts a variety of waterbirds that include the Glossy and Sacred Ibis, African Jacana, Redbilled and Cape Teal, Egyptian Goose and many others.

As well as harbouring a resident group of hippo, the Ngoitokitok Springs are frequented by a large population of Yellowbilled Kites, also known as African Black Kites. These birds are true aerial acrobats and, having become accustomed to being fed, swoop over the heads of visitors. Do not feed the birds as they will not hesitate to snatch food from the unwary, which can result in scratches. Feeding the birds also has a bad impact on them as they become dependent on food provided by visitors.

Vegetation – *Nature's Carpet*

The Ngorongoro Conservation Area encompasses a wide range of habitats, within each of which is an astounding diversity of plant life. There are six distinct vegetation zones in the Ngorongoro Crater alone – slopes, grassland, marsh, lakeshore, the riverine zone and forest.

On the slope of the Seneto descent into the Ngorongoro Crater, tall succulent trees, including *Euphorbia candelabrum* and *Euphorbia bussei*, line the roadside. When flowering they attract swarms of bees but the honey they produce irritates and burns the mouth and cannot be eaten.

The crater floor is predominantly grassland, composed of many different species including *Sporobolus* and red oat grass (*Themeda triandra*). In the rainy season the grasses are interspersed with a carpet of multicoloured flowers. The best time to enjoy the floral displays of the conservation area is during the rainy season but some species will be found in blossom at all times of the year. Look out for the orange flower clusters on the tall lion's paw or minaret (*Leonotis* sp.). Members of this genus occur very widely throughout sub-Saharan Africa.

Reaching up to two metres in height, the purple flowers and yellow fruits of the sodom apple (*Solanum incanum*) can be observed throughout the Ngorongoro Conservation Area. Although the numbers of small flowering plants are impressive, the grasses dominate the crater floor.

Grazing succession ensures that a range of vegetation species is maintained around the Mandusi Swamp. Elephant and buffalo eat the tougher grasses and sedges such as *Cyperus immensus*, hippo and zebra the weaker grasses, and gazelles the short grasses. Although Lake Magadi is alkaline, *Odyssea* grass grows along its shores, and *Spirulina*, the blue-green algae on which flamingos feed, thrives in the water itself.

One of the few trees that has roots strong enough to penetrate the layer of cemented limestone just below the surface of the lime-rich soil of the Serengeti Plain is *Acacia tortilis*, the flat-topped acacia tree that is so characteristic of East Africa. *Acacia mellifera* is known as the 'wait-a-bit' tree as its thorns easily snag the passer-by. Another species of acacia, *Acacia albida*, can be found on the edge of the Lerai Forest, often enveloped by the suffocating stems of the strangler fig.

The Northern Highlands Forest Reserve is a montane forest dominated by such trees as crotons (*Croton* spp.), white stinkwood (*Celtis africana*), muchorowe (*Nuxia congesta*), pillarwood (*Cassipourea malosana*) and red thorn (*Acacia lahai*). Because of its durability, the hardwood of these acacias is often used for construction. Tall pillarwood trees hung with old man's beard (*Usnea*) are also found in the forest. Old man's beard is a type of lichen that forms long, tangled, greenish-grey tufts hanging from the tree branches and those of larger bushes. It thrives in areas receiving the highest rainfall.

LEFT: *The Lerai Forest, which is dominated by yellow-barked fever trees, lies at the foot of the southwestern wall of the Ngorongoro Crater. Both the Ngorongoro Crater Lodge and the Wildlife Lodge are situated above this small forest.*
OPPOSITE TOP RIGHT: *The crinum lily is a large and showy bloom that appears during the rainy season.*
OPPOSITE TOP LEFT: *Largely restricted to the rocky cliffs, the magnificent red and yellow flowers of the leopard lily make it one of Ngorongoro's most dramatic plants.*
OPPOSITE BOTTOM: *An impala ram standing in acacia woodland, surrounded by flowers and green grass during the rainy season. This floral bounty is short-lived, and within a brief period after the rains, the plants cast their seeds and the yellows, blues and reds turn to bleached browns.*

A climber, *Senecio hadiensis*, is in evidence on the edge of the Northern Highlands Forest Reserve. This reserve, lying within the Ngorongoro Conservation Area and dominating the far southern and eastern slopes, plays a critical role as a water-catchment zone for the wildlife and peoples within the area and for the rich agricultural lands abutting its eastern borders. These farmlands form one of Tanzania's most important 'bread baskets' and as such support many thousands of people. The canopy throws its protective cover over the soil of the forest floor, preventing excess evaporation and allowing the substrate to absorb the water from the rains. Although some water flows by way of streams from the highlands, the sponge-like qualities of the soil allow this life-giving liquid to filter out over great distances, even during the dry season. Despite its importance to both man and beast, some illegal logging, bamboo cutting and burning does take place. Responsibility for the protection of this critical resource lies in the hands of the Ngorongoro Conservation Area Authority.

A number of acacias dominate the seasonal watercourses, and still others remain prominent features of the plains. Although a few African species are located in areas of high rainfall, most are adapted to surviving in dry conditions in areas with low and erratic rainfall. They are frequently the dominant trees of an area, and are therefore important sources of food for many antelope species. As well as the leaves, buds and flowers, the pods are highly nutritious and may form a large part of an animal's diet during times of drought. As a consequence, a great number of herbivores have access to food during difficult times and the acacias benefit by having their seeds dispersed over a wide area, having passed through antelope and elephant guts unharmed and ready for germination. It has been shown that acacia seeds that have passed through herbivore guts germinate faster than those that have not and they are far less susceptible to the activities of borer beetles and their larvae.

Acacia leaves and flowers form a major part of the diet of the Masai giraffe in the conservation area and the shapes of many trees have been modified by their frequent visits. Other species of antelope that feed from these abundant trees are eland, Grant's gazelle, impala and at lower levels the diminutive Kirk's dik-dik. Elephant are frequent visitors to acacia groves and solitary trees, as are the once widespread black rhino. Several small rodents, a number of bird species and numerous insects rely on the trees for sustenance and shelter.

In the western plains area, extending into the Serengeti, there are 'groves' of low and spindly acacias with marble-sized swellings at the base of many of the thorn pairs. These are known as the whistling thorn acacias (*Acacia drepanalobium*), and the swellings are galls inhabited by a species of ant that protects itself from predators by living among this spiny 'maze', obtaining food from the flower nectar. It seems to be likely that the whistling thorns, which are unharmed by these galls, derive a measure of protection from the aggressiveness of the ants, and the formic acid which the ants produce to defend themselves. Nevertheless the leaves, flowers and pods of these trees are eaten by species such as giraffe and Grant's gazelle.

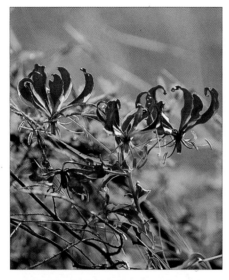

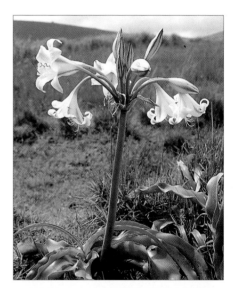

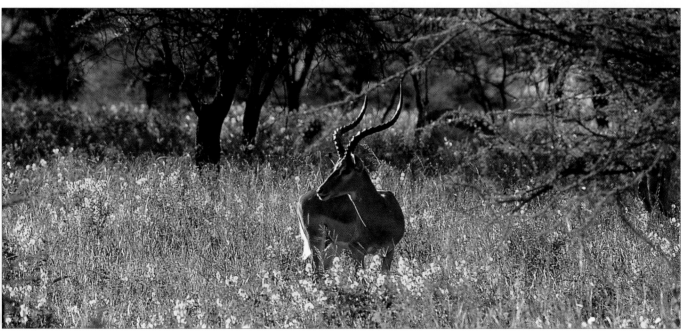

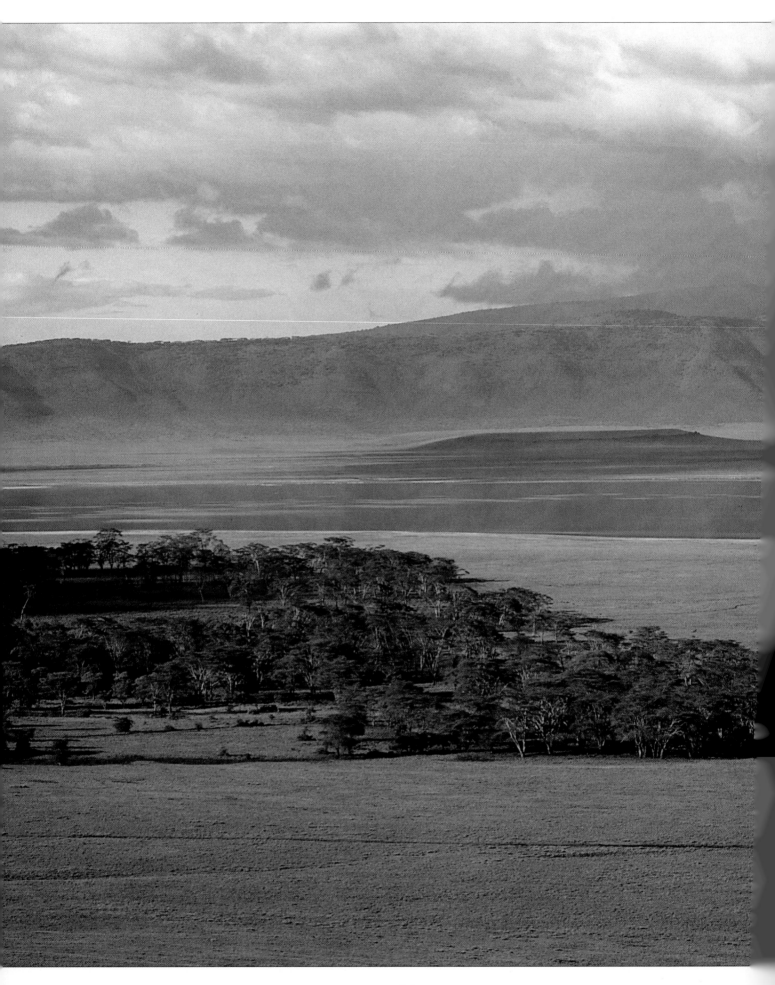

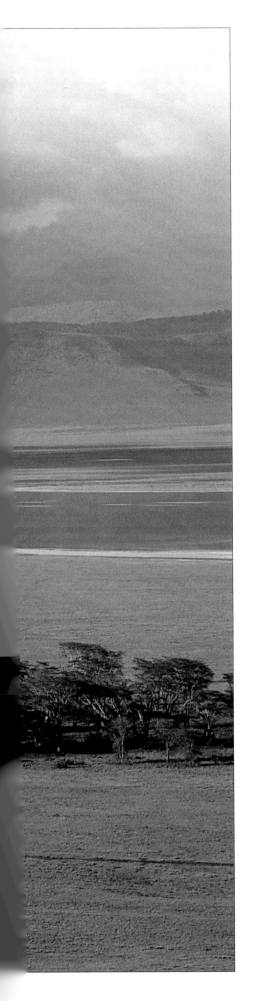

THE NGORONGORO CRATER

A Microcosm of East Africa

It has been described as one of the wonders of the world, and with justification. This gigantic caldera is the primary destination of most visitors and encloses in one place grasslands, forests, wetlands and slopes providing habitats for a host of creatures, large and small.

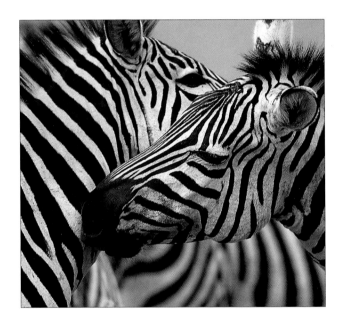

In 1978 the Ngorongoro Crater was declared a World Heritage Site in recognition of its uniqueness. Located on the southern boundary of the conservation area, this giant caldera is the principal destination of many visitors to Tanzania. It covers an area of 264 square kilometres, is about 14.5 kilometres across and ranges in depth from rim to floor from 610 to 760 metres.

Most visitors' first view of the Ngorongoro Crater is from the rich montane forest on the rim, looking down onto stretches of short and long grassland, swamps, streams, forests, low hillocks and the soda lake, Magadi. As you look over the crater floor for the first time you can hear the forest birds calling all around you, and on a still day you might even hear the far-off grunts and honking of hippo in the Gorigor Swamp. It is a magical viewpoint and it is a great pity that most visitors spend but a few fleeting moments here. If your time is not too limited consider spending a couple of hours absorbing the atmosphere of one of the world's greatest wildlife locations. Looking through binoculars, herds of buffalo, blue wildebeest, plains zebra and gazelle can be seen on the crater floor. Although the sides of the crater are steep they present no real barrier to most of the animals living there but the abundance of food and water throughout the year gives them little cause to leave.

The road that descends into the crater follows the western edge of the caldera rim, skirting the extensive grassland of the **Malanja Depression**. The Maasai graze their cattle in the shadow of the Sadiman volcano in the west. In the rainy season the Malanja

ABOVE: *Plains zebra can be found throughout Ngorongoro.*
OPPOSITE: *With the onset of the rainy season the vegetation on the floor of the crater undergoes a dramatic transformation, thus ensuring the survival of the vast numbers of herbivores.*

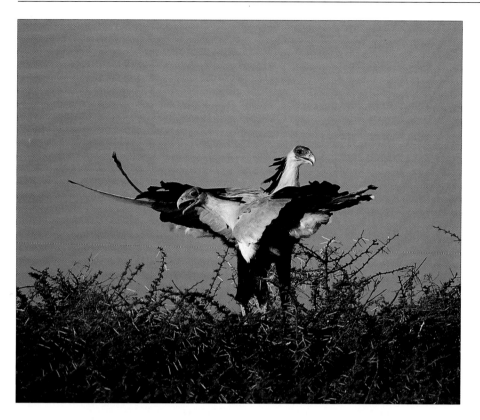

Depression is covered by a mass of yellow flowers. Driving from your camp or lodge towards the depression, you will encounter small groups of Maasai women and children at the roadside, and Maasai men with their cattle herds. Many of these people generate some income for themselves by posing for photographs; tourists have to pay for this privilege. Although the fee is often negotiable, a few such groups have a fixed fee.

The steep road descends further into the crater, following the incline of the depression, until it reaches Windy Gap, an opening which reveals the magnificent eastern view of the crater. At the foot of the descent road are the **Seneto Springs**. They afford one of the few opportunities for the visitor to get out of the vehicle (there is a pit toilet here, one of only three on the crater floor). The springs offer a good introduction to the wildlife of the area – on a recent visit, within half an hour we were able to observe elephant, buffalo, plains zebra, wildebeest and Grant's gazelle. The springs also attract many species

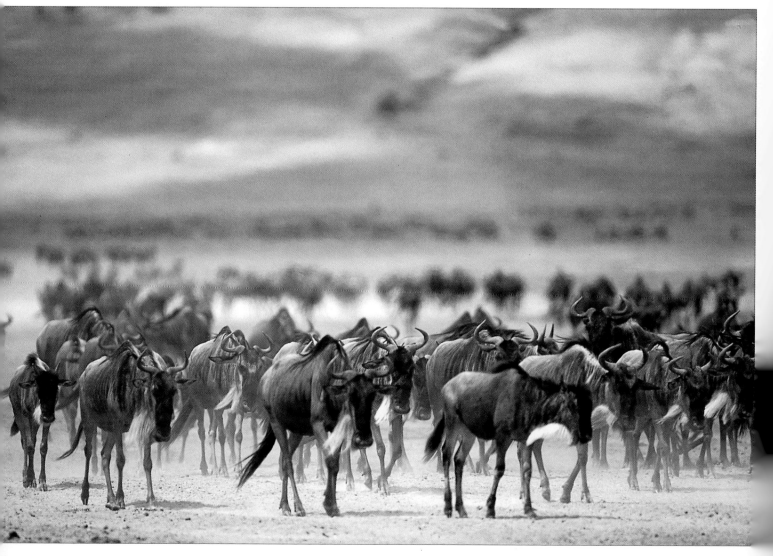

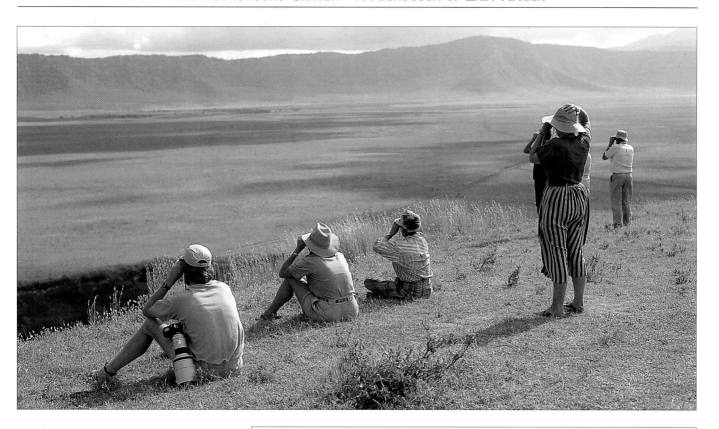

of birds and it is worth spending some time bird-watching before venturing further into the crater. Apart from a few conspicuous species, such as Crowned Plovers, Blacksmith Plovers and Whitebacked Vultures, many smaller species of birds, such as larks, inhabit the grass and bush cover close to the springs.

Many animals come to drink at Seneto Springs, and it is the only place on the caldera floor where the Maasai are allowed to water their catttle and goats. Exploring the Ngorongoro Crater is made easier by the network of roads and tracks which allows access to the important features within the basin. The guides usually know where particular birds and animals can be found.

ABOVE: *From Silali Hill visitors can look out over the plains of the Ngorongoro Crater; at 18 kilometres across, it is the largest perfect caldera in the world.*
OPPOSITE TOP: *Secretary Birds have been described as terrestrial eagles on stilts. Virtually all of their hunting takes place on the ground, where they seek out small mammals, lizards, snakes and invertebrates. They construct vast nests of sticks on low, flat-topped trees.*
OPPOSITE BOTTOM: *Although water is available at a number of locations within the Ngorongoro Crater, wildebeest and zebra, as well as other species, favour drinking at the point where Munge Stream enters Lake Magadi.*

The Lions of the Crater

The visitor to the crater is almost guaranteed sightings of lions **(below)** as so many occur and they often lie out in the open. Studies undertaken on the population of lions here have shown that very few actually enter the caldera and there is little reason for those already there to leave. The high level of inbreeding has resulted in an increased incidence of sperm abnormalities and the loss of some 10 per cent of the genetic diversity of the population.

In 1962 the lion population was reduced from an estimated 70 individuals to about 10 animals by a severe and prolonged outbreak of the biting fly *Stomoxys calcitrons*, the result of an unusually long rainy season which allowed the flies to proliferate for six months. However, by 1972 the lion population had fully recovered.

Although at present lion numbers are stable and cub mortality is not particularly high, there is the danger that any epidemic could devastate the crater population. Should this happen, however, it is almost certain that the rich bounty of the crater would successfully cause lions to invade the region from the hills and plains to the west.

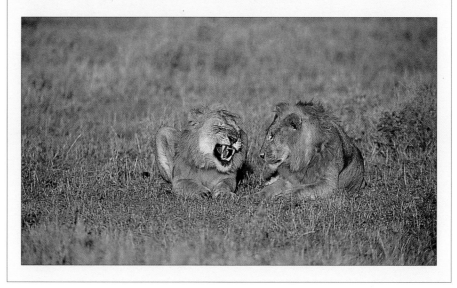

Any visitor, whether travelling with an organized safari or independently, is obliged to take an official guide to the crater floor. Guides must be arranged the day before a descent is planned and can be collected at the Ngorongoro Conservation Area headquarters at 07:00. No descent into the crater is allowed later than 12:00.

You will be charged at the entrance gates at Lodware or Naabi Hill, whether or not you decide to visit the crater floor. Those driving their own vehicles should be aware that road conditions are fair to good in parts but to enter the crater a four-wheel-drive vehicle is essential. The ascent and descent roads are very steep and fairly rough but on the floor the tracks are sandy and dusty. You will not get stuck here during the dry season.

Do not drive off the roads, nor try to influence your driver to do so, even if it means losing a prize photograph of a lion kill, or

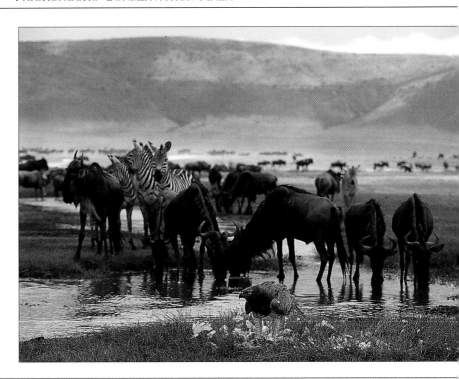

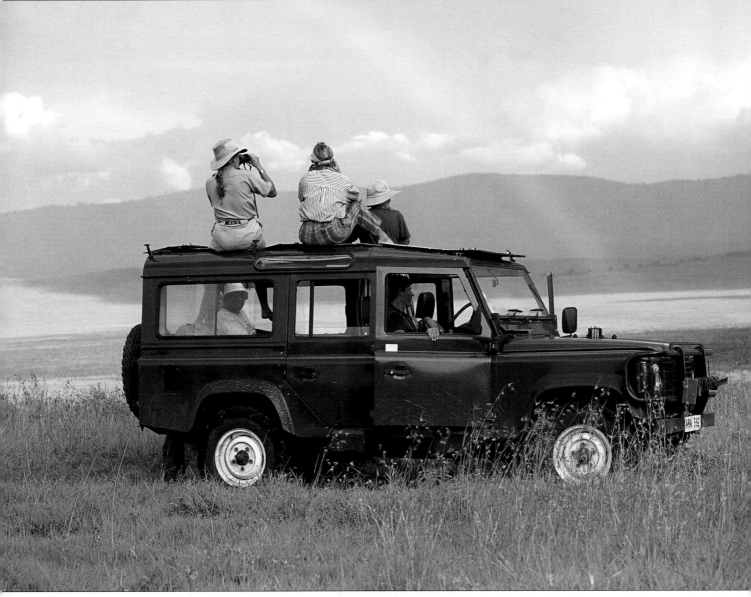

hyena cubs at the entrance to their den. There are very good reasons for this – it results in the destruction of vegetation and disturbance of wildlife and could also cause the vehicle to become stuck. For short periods during the rainy season, access roads to the crater floor may be closed due to dangerous conditions. Even if these are open great caution should be taken on the floor as some areas become very muddy.

There is very little shade at the bottom of the caldera, except for the picnic sites at Ngoitokitok Springs and at the Lerai Forest. You need to carry sufficient water for the day as no safe drinking water is available.

To make the most of your game-viewing and bird-watching, drive slowly or instruct your driver to do so, as this will reduce the amount of dust in the air and help you to make more detailed observations. You are also more likely to see the smaller species

this way. Although there are a number of places where the creatures of the crater can drink, it is well worth spending an hour or two at one spot and waiting patiently. For example, at **Hippo Pool** you are guaranteed good views of these large semi-aquatic mammals at close quarters, as well as the smaller creatures that feed around the pool fringes and the birds that come to drink.

North of the Seneto Springs is Engitati Hill. Before reaching the hill, however, it is worth stopping at the small pools known as **Goose Ponds**. This is the most likely place to see serval as they prey on the many rodents that inhabit the waterside vegetation.

Across the marsh is the Munge Stream. The river is a favourite bathing area for both vultures and eagles. Although many animals come to the stream to drink and hunt, it is not easy to spot them in the dense vegetation and thickets along the banks of the stream.

Munge Stream has its source in the Olmoti Crater, cuts through the northeastern slope of the crater wall, and expands into Mandusi Swamp. This marshy floodplain is home to a variety of water birds, as well as hippo, elephant and smaller mammals such as reedbuck. It is a favoured site for birds, a hunting ground for predators and a grazing area for plains zebra and wildebeest. Munge Stream flows out of the swamp to continue its journey to Lake Magadi. Hundreds of wildebeest and plains zebra gather to drink at the place where the stream enters the lake, sloshing their way through the mud to gain access to the freshest water flow.

To sit quietly at the point where the stream enters the lake, particularly in the dry season, is as enthralling an experience as can be had anywhere in the Serengeti and Masai Mara. The herds churn the fine soda dust and silts with the plodding of thousands of hooves,

OPPOSITE TOP: *Wildebeest drinking at Munge Stream. Birds of prey, such as this Martial Eagle, hunt small animals that come to the stream.*
OPPOSITE BOTTOM: *Tourists looking out over Engitati Hill, lying to the north of the Mandusi Swamp.*
RIGHT: *Small populations of hippo spend the daylight hours in the Mandusi and Gorigor swamps.*
BELOW: *The Mandusi Swamp is home to hippo and a wide variety of waterbirds.*

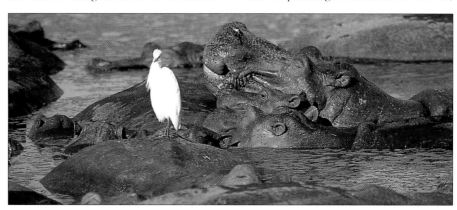

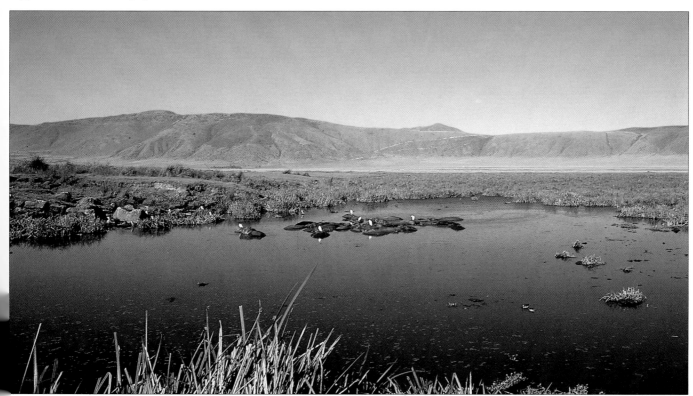

wildebeest grunt and zebra stallions bark. The animals emerge from a cloud of dust and jostle vigorously with each other for access to the cleanest drinking water. The first animals to reach the water turn away after slaking their thirst and those that follow are forced to drink from the increasingly muddied waters. Because of the thick mud the tiny Thomson's gazelle, with its delicate legs, does not venture far from the shore, and often has to make do with muddied puddles churned up by its larger relatives.

It is at this time, when the antelope and zebra are drinking, that they are particularly vulnerable to predation by lion and spotted hyena. Yet they are less exposed here than if they were to drink along the Mandusi Stream, a place favoured by lions; here some shade is offered, a scarce commodity over much of the crater floor.

The amount of water flowing from the highlands into Munge Stream determines the level of **Lake Magadi**. When full, the lake attracts many birds and animals, and is home to flocks of flamingos (mainly Lesser). The margins of the lake are the haunt of lion, hyena and golden jackal, which prey on the waterbirds. Some golden and black-backed jackals prey almost entirely on flamingos when they are present and clouds of pink and white feathers indicate the sites of these feasts. Even spotted hyena and lion are not averse to preying on flamingos when the opportunity presents itself, although with such an abundance of food available to them in the crater this is a rare occurrence.

Although Lake Magadi diminishes considerably during the dry season (from June to October), this soda lake is still well worth seeing, if only for the spoor imprinted along the shore and the dustdevils that whirl over its shimmering surface and around its edges.

Another area of water in the crater is the **Ngoitokitok Springs** at the base of the southern slope. The springs run into the Gorigor Swamp, a refuge for many waterbirds. This swamp is a prime destination for the keen birder. The road between the Ngoitokitok Springs and the crater ascent skirts the western fringe of the swamp, and a low bridge crosses the principal outlet. There are areas of open water, muddy banks, short sedges and extensive reedbeds located mainly along its eastern extremities. Within a few hundred square metres you might observe elephant, buffalo and hippos wallowing and feeding. These are usually attended by oxpeckers, specialized birds that feed on ticks, horseflies and other external parasites that pester the game animals. There are two oxpecker species, the Redbilled Oxpecker and Yellowbilled Oxpecker. Each feeds on ticks in different ways, the former using the beak like a pair of scissors, the latter plucking them off the host mammal.

RIGHT: *The flamingos that feed in the shallow waters of Lake Magadi do not breed here but are probably part of the much larger populations that spend most of their time at such lakes as Natron, Nakuru and Bogoria to the north. Lesser Flamingos are more abundant in Lake Magadi than Greater Flamingos.*
BELOW: *Two full-maned lions in their prime, with a freshly killed bohor reedbuck ram. Lions hunt all types of antelope, including wildebeest.*

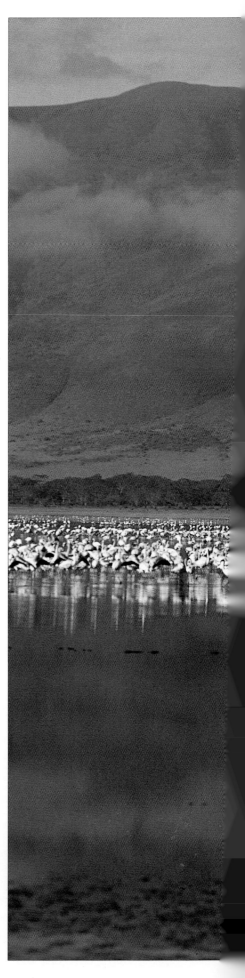

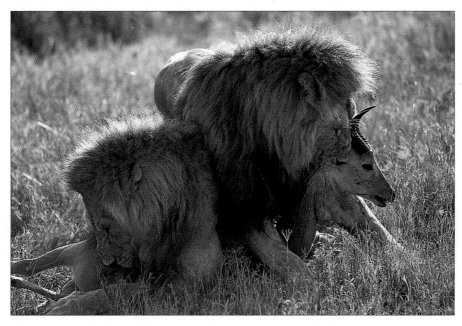

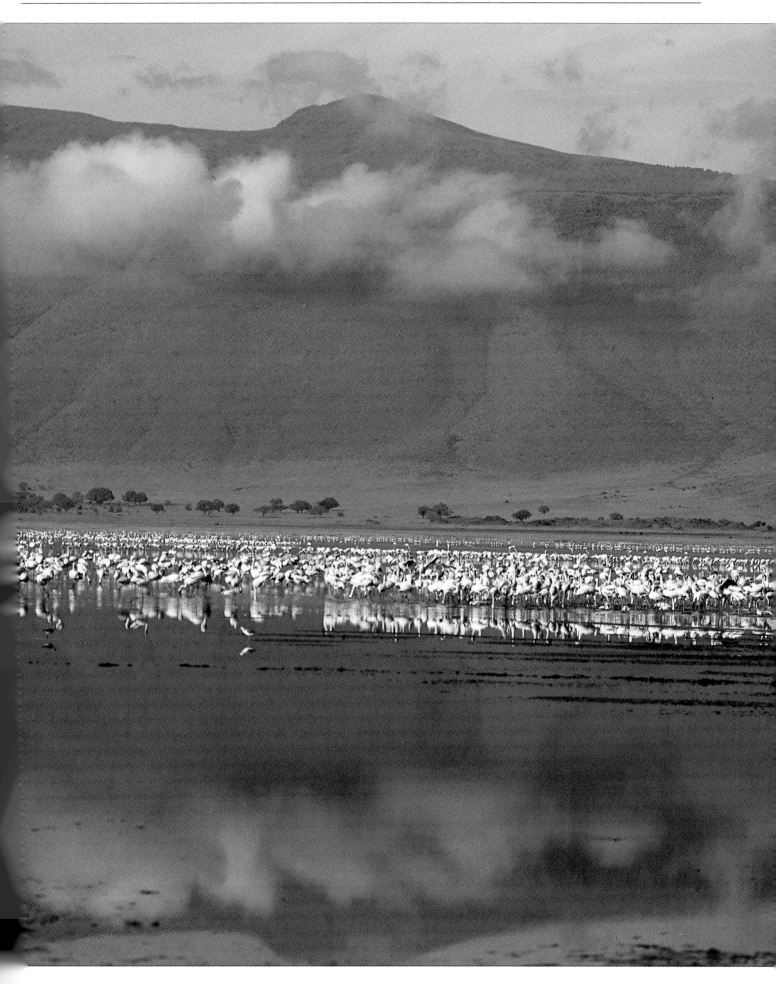

The waterbirds are the main attraction of the Gorigor Swamp. Some species are present throughout the year, such as the Grey Heron, Hamerkop, Egyptian Goose and several different plovers. Others only arrive with the onset of the rains.

Another resident of the Gorigor Swamp (and other marshy areas) is the African Jacana, which has oversized feet that allow it to walk over the floating vegetation seeking out its insect, crustacean and mollusc prey. It is therefore able to reduce any potential competition with the larger birds that would sink if they attempted to follow its example. The Black Crake is the only other species, with the exception of such lightweights as the wagtails, that is able to prowl the floating mat. Competition between the two species is largely avoided as the Black Crake rarely forages far from the dense reedbeds which the African Jacana tends to avoid.

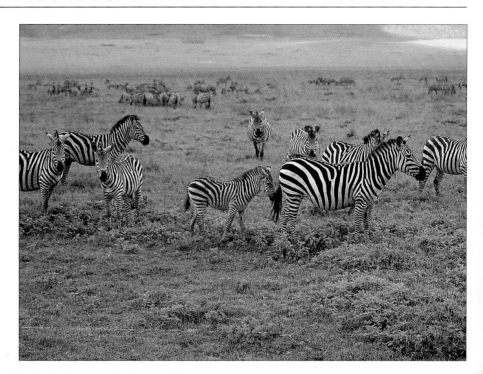

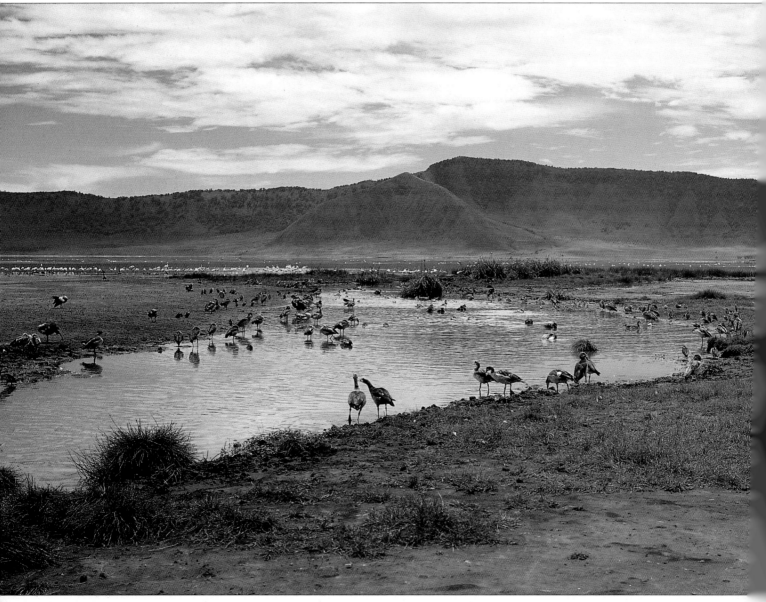

OPPOSITE TOP: *Plains zebra may temporarily form loose herds of several hundred individuals but the integrity of the small permanent family groupings is always maintained.*

OPPOSITE BOTTOM: *The appropriately named Goose Ponds are a refuge for Egyptian Geese and other waterbirds such as Saddlebilled Storks and African Spoonbills. The ponds are also the haunt of serval cats as well as lions and hyenas, who prey on these birds.*

RIGHT: *Black rhino, reduced to a fifth of their former numbers in the Ngorongoro Crater by poachers, are easy to observe because of the nature of the terrain and the fact that much of their time is spent feeding out in the open.*

BELOW: *Herds of wildebeest, plains zebra, gazelles, kongoni and buffalo roam the Ngorongoro Crater floor.*

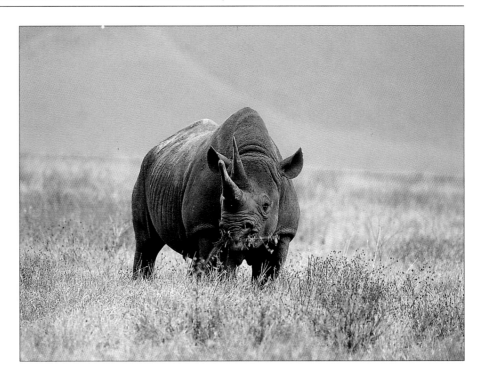

As no one is allowed to camp on the crater floor the numerous frogs and toads, an important group of animals that occupies the swamps, marshes and streams (but not the inhospitable waters of Lake Magadi), are usually overlooked, except when rain has fallen and they are more conspicuous.

The excess water from the Gorigor Swamp is carried into Lake Magadi via an outlet from the swamp, which is also a good place to see black rhino. The Ngorongoro Crater is one of the few places left in East Africa where the visitor may easily observe this endangered species. Rhino are generally classified as browsers, but within the Ngorongoro Crater grass makes up a large percentage of their diet and individuals are frequently seen on the open grasslands. As a result of being poached for their horns, numbers have declined from some 100 individuals to a mere 20. Although numbers are still dangerously low, anti-poaching efforts in Ngorongoro have helped to stabilize the population.

The Ngorongoro Crater is managed as an integral part of the Ngorongoro Conservation Area, and all management policies, anti-poaching patrols and guiding is coordinated by the **Ngorongoro Conservation Area Authority**, whose headquarters are located close to the southern rim of the crater. In the past poaching has gone largely unchecked, particularly that of such valuable animals as the black rhino and the elephant. However, in recent times greater foreign interest and funding has flowed into East Africa, including Tanzania, in an effort to stem the illegal hunting and trade in rhino horns and elephant ivory. In the case of the latter, efforts have been largely successful but the rhino numbers continue to decline. Stepped-up anti-poaching patrols within the crater have allowed the few surviving black rhinos to creep back from the brink of extinction and several calves have been born.

Because of the relatively closed nature of the Ngorongoro Crater, it is fairly simple to keep tabs on the remaining animals but it is unlikely that others survive in the rest of the

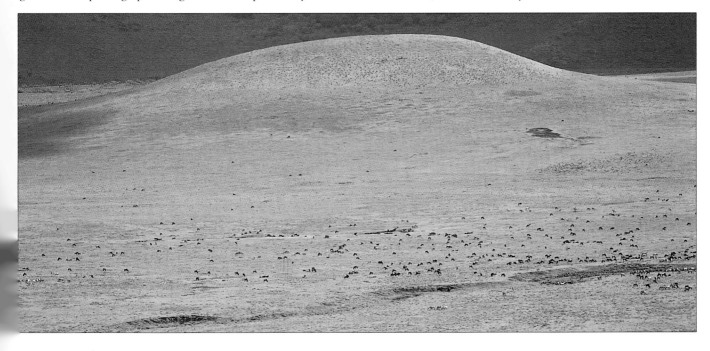

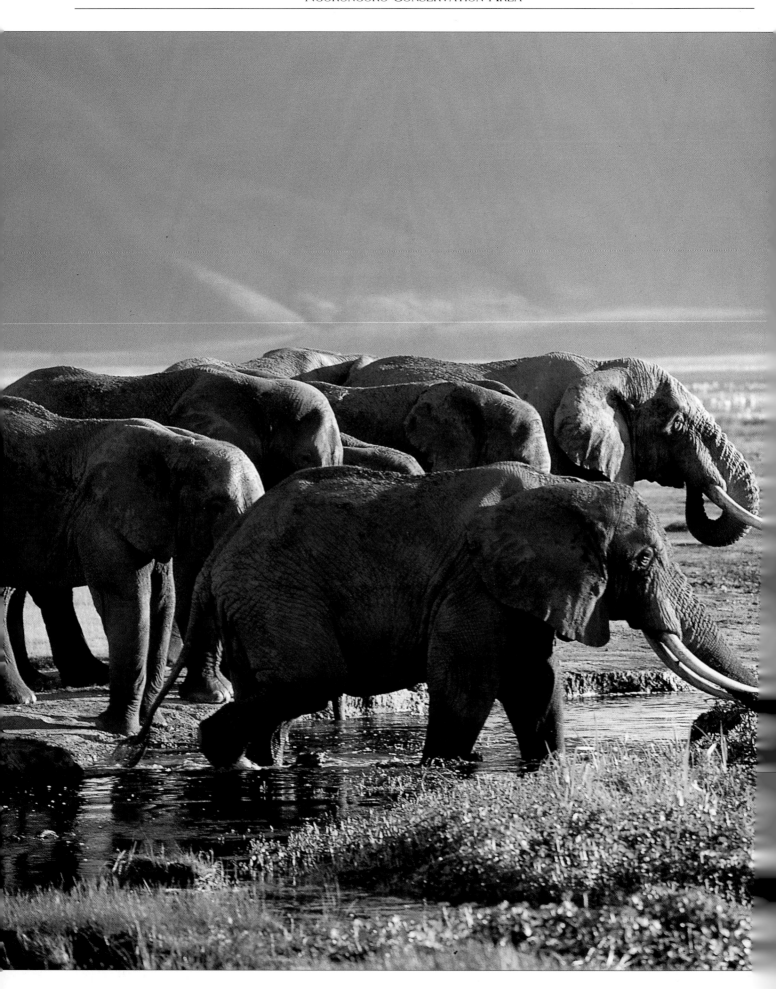

conservation area. In the past, black rhino occurred widely in the region wherever there was suitable bush cover and food, and it is hoped that in time the rhino populations will again reach pre-poaching levels.

Elephants are still vulnerable to poaching. Although commonly seen in the crater, nearly all the elephants on the crater floor are bulls. Matriarchal herds of cows and calves frequent the forest on the rim of the crater but they rarely make the descent. The walls of the caldera are steep around its entire circumference and although this is not a formidable barrier to adult and adolescent elephants, it constitutes a major climb for calves. It is almost certainly for this reason that adult cows, invariably accompanied by calves of different ages, avoid the steep descent. There is an abundance of food in the forests, as well as on the grassed plains, particularly during the rainy season. The elephant bulls

on the crater floor are usually seen feeding in the swamps and marshes, and are also frequent visitors to the Lerai Forest.

The ascent road climbs the southern wall of the crater. It follows a route through plants and bushes that are very attractive when in flower. The road then leads into a gorge where trees such as the Cape chestnut grow. Looking back, there are dramatic views of the crater all the way up to the forested rim.

OPPOSITE: *Bull elephants move freely into and out of the crater, attracted by its abundance of food and water. Elephants have a complex social structure and move in large herds. Males form bachelor groups when they reach adulthood, returning to the herd when a female is in oestrus. They are widely distributed and frequent most types of habitat, from savannah to swamp.*

The Lerai Forest

Within the crater, the Lerai Forest at the foot of the ascent road could be a wildlife sanctuary in its own right as it is a refuge for a variety of birds and animals. *Lerai* is the Maasai name for the yellow-barked acacia (*Acacia xanthophloea*) of which the forest is primarily composed. The rate of growth of this acacia is highly dependent on the water level. In fact, its association with water (also the breeding ground for mosquitoes) led early travellers to link this acacia with malaria, hence the common name,

'fever tree'. The base of the trunks of many of the larger trees is gnarled and lumpy as a result of elephants stripping the bark. Solitary elephant bulls **(below)** and small bachelor groups are often seen in the forest.

The fig trees in the northwest of the forest are sacred to the Maasai and the Datoga people and one of them in particular is revered as a burial site. It is believed that a warrior from the Datoga tribe was wounded in battle in around 1840, and that the fig tree grew in order to give him shade.

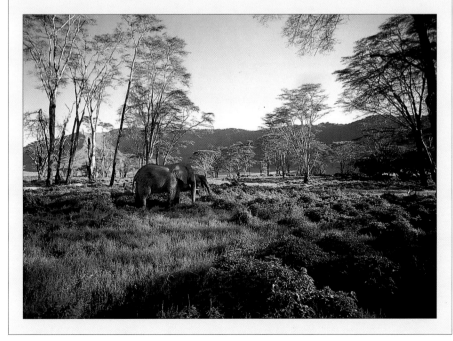

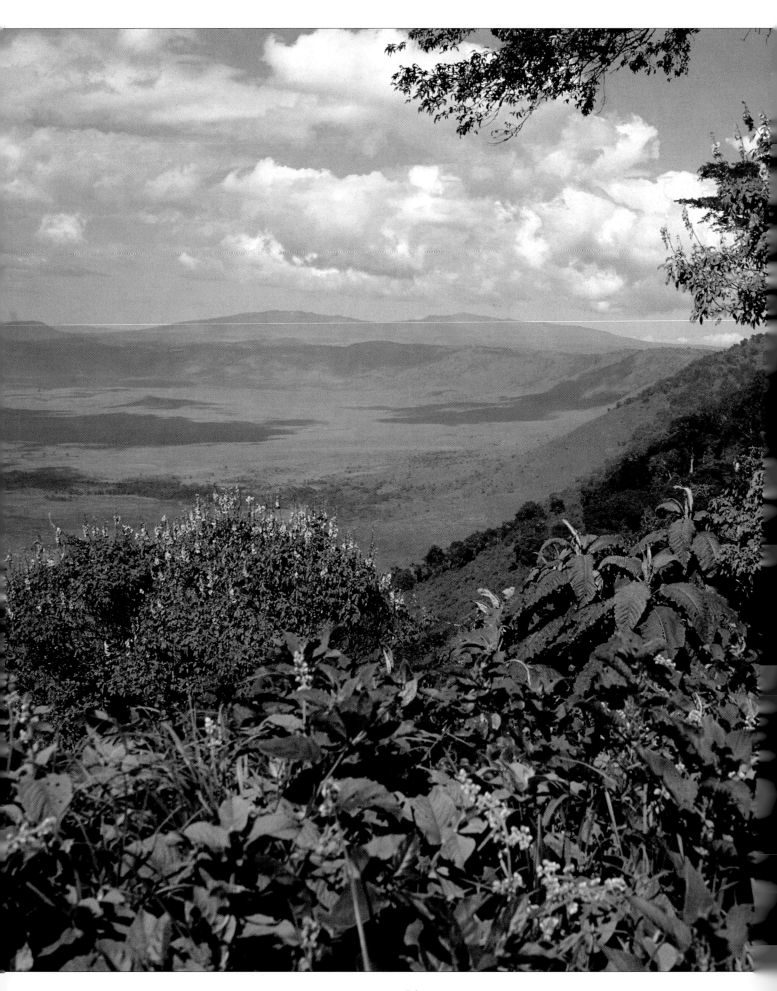

THE HIGHLANDS AND THE PLAINS

Tall Trees and Short Grasses

From the montane forests of the highlands, a critical water catchment area and the home of the black-and-white colobus monkey and vociferous tree hyrax, the land sweeps down to the wide plains, a sea of grass roamed by vast migratory herds of ungulates accompanied by large carnivores.

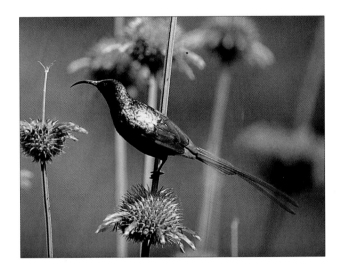

Approaching the Ngorongoro Conservation Area from the southeast, the visitor encounters high ridges clothed in dense forests. However, if the route taken passes through the Serengeti National Park, the approach is then across immense sweeping plains and grasslands, extensions of those in the park itself.

The forests and eastern slopes of the Ngorongoro highlands receive their rains from the moisture-laden winds that sweep in from the distant Indian Ocean. However, the western plains fall directly within the rain-shadow and during the dry season the grasses and shrubs are brittle and brown. It is precisely this diversity in the region's topography and vegetation that allows such an impressive array of animal and plant life to survive and thrive here.

It is difficult to imagine today that the lush green and wooded slopes of the highlands were once the scene of violent tectonic activity. Great slabs of earth were thrust upwards, while others slid inexorably inwards. This faulting enabled volcanic activity to take place on a massive scale as the earth's crust weakened. Poisonous gases escaped into the atmosphere and the entire area was blanketed with a mantle of powdery ash.

These fertile volcanic soils have attracted large numbers of agriculturalists to the eastern boundaries of the Ngorongoro Conservation Area. They have also given rise to a variety of grasses and other plant life which have sustained the ungulate herds of the western plains. In 1911, Jaeger, the German explorer, hunter and naturalist, wrote: 'And all this a sea of grass, grass, grass, grass and sky.' When the grasslands are covered with new green growth, herds of wildebeest, plains zebra and Thomson's and Grant's gazelles stretch as far as the eye can see.

ABOVE: *A male Bronze Sunbird feeding on nectar from the flowers of the plant* Leonotis nepetifolia.
OPPOSITE: *There are several sites along the edge of the caldera rim that offer magnificent views of the crater floor, in this case looking northeast.*

Both Olmoti and Empakaai craters lie in the eastern sector of the conservation area and are approachable by tracks suitable for four-wheel-drive vehicles. There are ranger posts at the base of each crater where it is obligatory to hire a guide, but visitors who wish to camp must first secure permission from the conservation area headquarters. At **Olmoti** it is a short walk to the crater rim which looks down onto the grassy floor and the Munge Stream flowing southwards into Lake Magadi. It is well worth the effort to walk to the southern slope of Olmoti where the Munge River cascades from the crater rim. This impressive waterfall gave the river its name – *munge* is the Maasai name for the anklets worn by warriors, made out of the hair of the black-and-white colobus monkey. The fall of the monkey's tail suggests the fall of the water as it leaves the crater.

Empakaai is arguably one of the most picturesque locations within the Ngorongoro Conservation Area, as almost half the crater floor is taken up by one of East Africa's deepest soda lakes – it is about 85 metres in depth. The rim of the caldera is forested and includes such trees as the high-altitude mumondo (*Hagenia abyssinica*), as well as many species that are present on the ascent from the Lodware Gate. From the rim, on a clear day, there are magnificent views of the active volcano, Ol Doinyo Lengai. to the northeast, as well as of Lake Natron and Mount Kilimanjaro. Although the concentration of game at the crater is not very high, there is a chance of seeing buffalo and several species of antelope, as well as forest-dwelling species and waterbirds.

Although **Lake Natron** lies to the northeast of the Ngorongoro Conservation Area, beyond the 2 942-metre-high volcano, Ol Doinyo Lengai, it is a dominant feature of the region and deserves further mention. The flamingos that feed at Lake Magadi on the Ngorongoro Crater floor breed at this large, shallow soda lake. The glutinous muddy waters of Lake Natron make it one of East Africa's least hospitable areas for tourists, but to the flamingos, particularly the Lesser Flamingo, it is a paradise. Disturbance by predators is limited, food is plentiful both here and in other lakes lying within easy flying distance (including Lake Magadi) and the mud they need to construct their conical nests is found here in great abundance. Conditions are not always ideal for these graceful birds and consequently breeding does not take place every year.

Oldeani, a volcano lying just to the southwest of the Ngorongoro Crater, is known as 'bamboo mountain' and a stream rising on its eastern slope feeds down to the Lerai Forest on the crater floor. The stream is also the source of the water used by the lodges and the people who live around the conservation headquarters. From the west it pours its

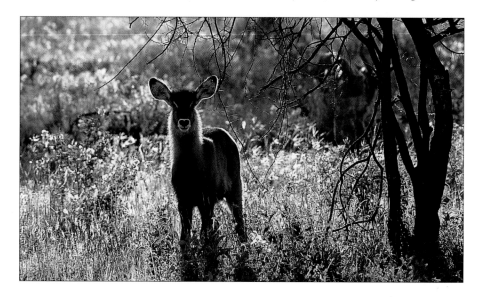

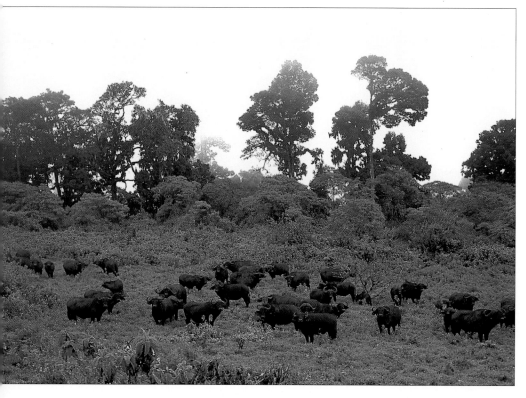

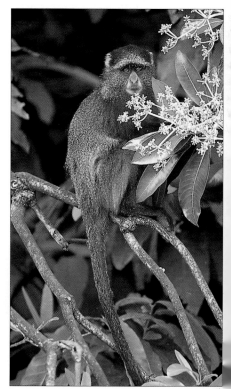

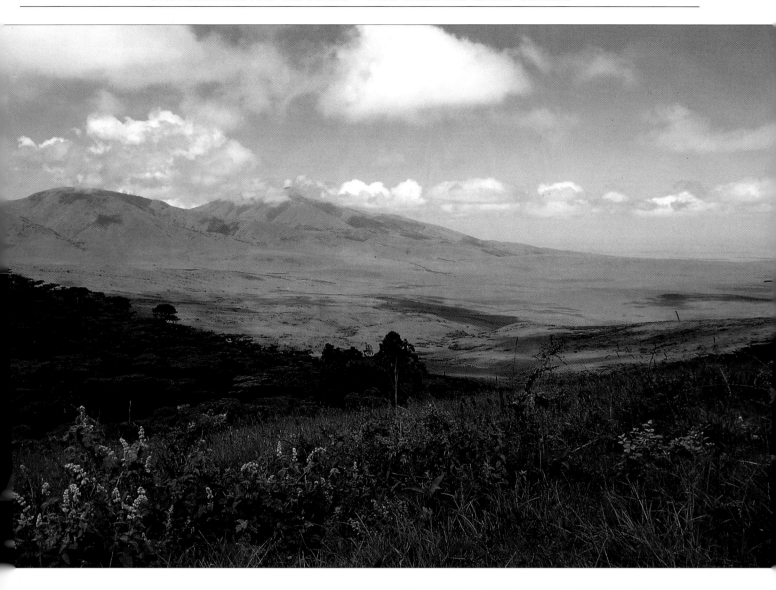

...e peaks of Lemagrut and Sadiman.

...OP: *Defassa waterbuck have scent glands*
...*te their presence.*

...OTTOM LEFT: *Buffalo are concentrated*
...*ern forests and on the crater floor.*

...OTTOM RIGHT: *The blue monkey's habitat*
...*d to the highland forests.*

...*k's dik-dik is a tiny antelope.*

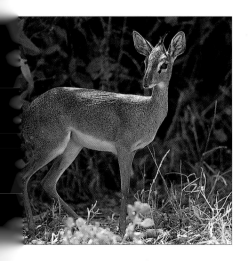

Bernhard and Michael Grzimek

Through the efforts of well-known zoologists Dr Bernhard Grzimek and his son Michael, Ngorongoro and Serengeti are protected areas today. The Grzimeks undertook the first ecological surveys of the area in the 1950s. A component of the surveys helped to establish the parks' boundaries as it showed that if the movement of migratory animals were restricted, the whole population would be threatened. The surveys, together with Bernhard Grzimek's book *Serengeti Shall Not Die*, also served to focus the world's attention on the area and arouse interest in conservation in general.

Tragically, Michael Grzimek was killed during the filming of the book. His father devoted the rest of his life to working with wildife and conservation.

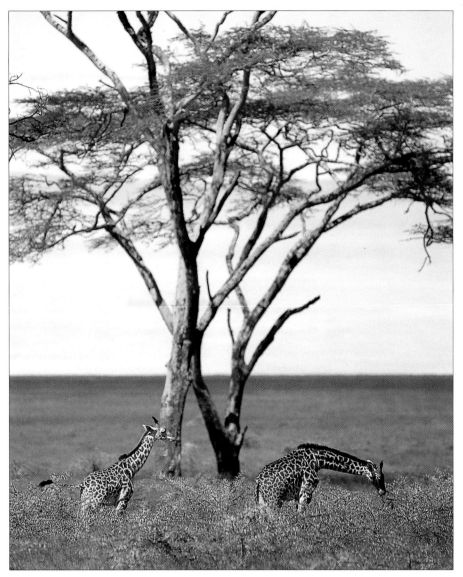

waters down to Lake Eyasi, which forms much of the southwestern border of the conservation area. The back wall of the lake is formed by the Eyasi Rift.

Leaving the western rim of Ngorongoro and heading northwest towards Serengeti, the visitor will come across the landmark peak of **Lemagrut**, and in its shadow the smaller **Sadiman** on the left-hand side. It was the ash from eruptions of Sadiman that preserved the footprints at Laetoli to the west, giving us further insight into our distant ancestors and the creatures that shared their domain. The slopes of these mountains draw up water from the rains. This water feeds out to springs in the north and west, providing important watering sites for the Maasai cattle and the plains game. Remnant stands of the

OPPOSITE TOP: *Ruppell's Vultures breed on the cliffs and a large colony is located in the Olkarien Gorge.*
OPPOSITE BOTTOM: *More than half a million Thomson's gazelles feed on the short grasslands of the Ngorongoro-Serengeti ecosystem.*
LEFT: *Masai giraffe feed mainly on the leaves and flowers of acacias.*
BOTTOM LEFT: *A series of low granitic outcrops lies close to the boundary of the conservation area and the Serengeti.*
BELOW: *During the courtship display of the male Kori Bustard, the tail is cocked over the back and the neck is inflated.*

beautiful African pencil cedar can still be found in the deeper gullies on Lemagrut. It is likely that these are survivors of more extensive forests but frequent burning and cutting for wood have taken their toll. These and other areas of grasslands are burned by the pastoralists in order to promote fresh grass growth at the onset of the rainy season. This proves attractive to cattle, as well as plains zebra and several antelope species such as Thomson's and Grant's gazelles.

On the grasslands, particularly on the floor of the Ngorongoro Crater, warthog are plentiful and easily seen during the day, while in the highland forest and dense thickets bushpigs, emerging to forage mainly at night, are seldom seen. The giant forest hog may occur in the main forest block but it has never been reliably reported. It is the world's largest wild swine – adult boars average 235 kilograms in weight. In view of its presence in similar forest pockets in adjacent areas, it seems likely that it could occur but this would probably be in very small numbers.

The remote northern areas should only be visited with a person who is familiar with them, such as a reliable local guide. The tracks are rough and require careful driving and it is not advisable to try and get there and back in a day. The ancient **Gol mountains** are an ideal destination for the visitor who enjoys isolation and solitude. From this area forays can be made onto the **Salei Plains**. This is particularly rewarding when the herds of wildebeest arrive to calve during the rainy season. To camp in the area it is necessary to obtain permission from the conservation area authorities.

The **Olkarien Gorge** lies on the western fringe of the Salei Plains, to the east of the Gol mountains and close to the northern boundary of the conservation area. The entrance to the gorge lies just to the west of the road (perhaps track would be a better description) leading to the village of Malambo. The steep walls of the gorge are an important nesting and roosting site for one of the most attractively marked vultures, Ruppell's griffon. Breeding takes place in March and April when game concentrations are highest. Other vulture species in the Ngorongoro Conservation Area are the Whitebacked, Lappetfaced, Whiteheaded, Hooded and Egyptian. Flocks of vultures of several species may be seen soaring in thermals over the grass plains in search of carcasses from which to feed. The different vulture species avoid feeding competition to a certain extent by specializing in different parts of the carcass. Ruppell's Griffon and the Whitebacked Vulture feed mainly on the large, soft body parts, whereas the Lappetfaced and Whiteheaded Vultures use their powerful beaks to tear and rip off tough, sinewy meat. The more finely beaked Hooded and Egyptian Vultures pick up smaller fragments around the kill that are generally overlooked by the larger vultures.

Egyptian Vultures have also been seen smashing open ostrich eggs using stones held in their beaks. Despite popular belief, at least two of the vultures, namely the Lappetfaced and the Whiteheaded, have been observed and recorded killing their own prey, but this is known to be rather unusual behaviour.

At the southwestern tip of the Gol mountains, **Nasera Rock**, a prominent granite outcrop, rises some 100 metres from the plains. It has proved to be an important archaeological site as over the centuries it has provided shelter from the harsh winds of the plains for animals and humans alike. During the rainy season it serves as an ideal lookout to observe the teeming herds of plains game. The rock supports a wealth of birdlife and is used as a nesting site by Lanner Falcons.

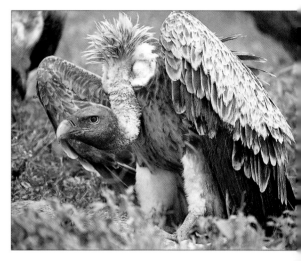

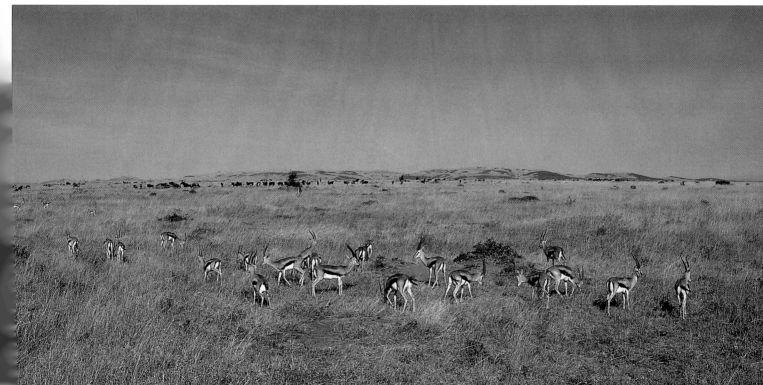

GETTING THERE

The usual approach to the Ngorongoro Conservation Area is from the town of Arusha, about 180 kilometres to the north. The first 80 kilometres are on good tar road, but the rest is on rather poor quality gravel road. The gravel leads to the village of Mto-wa-Mbu on the edge of Lake Manyara National Park – petrol and diesel are available in the village. The road climbs to the top of the rift wall, passes through densely populated agricultural land and enters Ngorongoro at the Lodware Gate.

The only other official entry point into the area is from the Serengeti National Park. The distance by road from the park's headquarters to the headquarters of the Ngorongoro Conservation Area is 152 kilometres on a fairly good, all-weather gravel road, although this is corrugated in parts. Entry into the Ngorongoro Crater is by four-wheel-drive vehicle only and all side tracks elsewhere are unsuitable for two-wheel-drive vehicles. Various tracks, largely impassable during the rainy season, enter the area from the north and southwest. These numerous tracks are in remote areas and can be confusing – it is therefore not advisable to negotiate them without being accompanied by a guide. Special permission is required if you enter by any of these alternative routes.

It is also possible to fly in to the airstrip on the crater rim, some three kilometres from the headquarters. Details of the various safari companies that offer this service, as well as tours of the northern Tanzanian parks and conservation areas, can be obtained from a travel agent. Most companies offer transport, accommodation or camping, and collection from the airport. Those visitors using their own aircraft can hire vehicles with drivers at the headquarters. Ndutu Lodge, overlooking Lake Ndutu on the Serengeti border, has its own airstrip and several strips for light aircraft lie outside the conservation area.

ENTRY REQUIREMENTS

All visitors need a valid passport to enter Tanzania. All visa requirements should be checked with your travel agent, or the Tanzanian representative in your country. If you are travelling with your own vehicle into Tanzania, you will require a *carnet de passage*, insurance cover and an international driver's licence. It is also necessary to purchase a foreign vehicle road permit at the border and pay a road toll tax. It is advisable to check on all your documentary requirements well before the trip.

It is not necessary to make reservations in advance to enter the Ngorongoro Conservation Area, and entry permits may be obtained at the Lodware Gate, the Naabi Hill Gate in the southern Serengeti and the conservation area headquarters at Ngorongoro. Non-Tanzanian residents are required to pay any fees in US dollars. If you intend going into the Ngorongoro Crater you are obliged to take an official guide with you at an additional fee. Guides are based at the conservation area headquarters. All entrance fees are valid for a period of 24 hours only. If you leave only an hour or two after the expiry of the 24-hour period you will be charged the full amount once more.

The gates into the Ngorongoro Conservation Area open at 06:00 and close at 19:00, but movement is allowed after dark between the campsites and the lodges. Take your rubbish away with you, or leave it at one of the lodges. Remember that potentially dangerous animals roam throughout the area and so it is advisable to be cautious. If you photograph Maasai people you must first ask permission and you will be expected to pay.

Most visitors to the Ngorongoro Conservation Area include a visit to the adjacent Serengeti National Park in their itinerary. This is a vast conserved area, covering almost 15 000 square kilometres, and together with Ngorongoro, Masai Mara and adjoining game reserves, forms a block of land that is critical to the wellbeing of the great herds of game and the ever-present predators. The western plains of Ngorongoro are a natural extension of the extensive Serengeti Plain and it is within this system that the wildebeest, plains zebra, topi, hartebeest and gazelles undertake their seasonal movements.

There are two principal entry points into the Serengeti National Park, the most heavily used at Naabi Hill Gate between Ngorongoro and the park, and the other into the western corridor at Ndabaka Gate close to the eastern shore of Lake Victoria. On most maps the

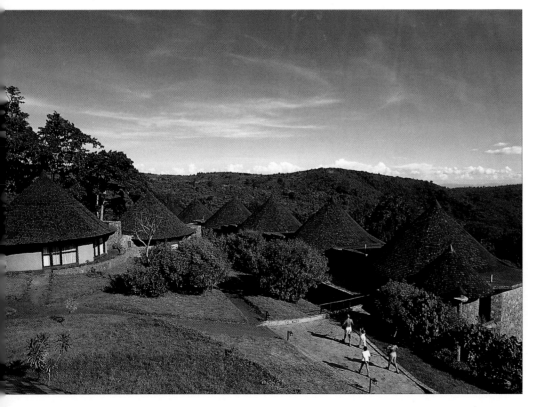

LEFT: *The Ngorongoro Sopa Lodge is situated on the crater rim. It boasts magnificent views of the Ngorongoro Crater and its forested location guarantees rewarding bird-watching.*
OPPOSITE: *Of the three lodges on the crater rim, the Ngorongoro Crater Lodge is the most attractive and the one that least impinges on the natural surroundings. Buffalo and plains zebra are frequently seen wandering across the lawn or between the buildings.*

Bologonja Gate, at the border between Serengeti and Masai Mara, is marked but entry here is not recommended. People have been turned back at the border as it is no longer an official crossing point.

ACCOMMODATION AND FACILITIES

Simba is the Conservation Area Authority's only campsite on the crater rim. It has pit toilets and showers that are usually overworked, very little shade and the campsite is frequently very crowded. Nevertheless, it is a nice location and a short walk away are excellent views into the crater. Buffalo, elephant and lion frequent the rim woodlands and you should move with caution. The camping fee is steep but is still considerably cheaper than staying in the lodges. If you stay at the Simba campsite you can visit the lodge bars and restaurants after dark, but drive with caution as many animals move through the area at night.

There are two privately run camps, one near Olduvai and the other in the vicinity of Ndutu, both of which charge double the rate of the conservation authority camp. To stay at these campsites it is necessary to book in advance with the tourism office at the conservation area headquarters. Although many of the guide books indicate that camping is allowed at designated sites on the crater floor, this is in fact no longer the case – they were closed due to disturbance of the wildlife. There are no plans to reopen them. Camping is not allowed elsewhere in the Ngorongoro Conservation Area without special permission, and if granted, you will probably be obliged to take a guide.

There are currently four lodges around the rim of the Ngorongoro Crater: Crater Lodge, Wildlife Lodge, Rhino Lodge and Sopa Lodge. Near the descent road into the crater is the Ngorongoro Serena Lodge, which was still under construction at the time of writing. Ndutu Lodge, the only other lodge in the conservation area, lies in the northwest, bordering on the Serengeti National Park. Although advance booking is recommended at the lodges, the casual visitor probably stands a good chance of securing accommodation as it is unlikely that all of them will be filled to capacity at any one time.

If you are entering the conservation area from Arusha and you wish to break your journey, there are three alternatives. The Lake Manyara National Park offers 'rondavels' and cooking and ablution facilities, as well as a campsite at the park entrance. The park

headquarters lie just beyond the village of Mto-wa-Mbu and are clearly signposted. The Lake Manyara Hotel (Tanzania Hotels Investment, PO Box 877, Arusha, Tanzania) is situated above Lake Manyara, on the edge of the escarpment, and has excellent views over the lake and plains. The approach road is badly corrugated and it is necessary to pass through a squalid curio 'village' on the way, but the hotel is pleasant. Gibbs' Farm (Ngorongoro Safari Lodge, PO Box 6084, Arusha, Tanzania) lies on the outer slopes of Ngorongoro among coffee plantations and forest. It offers 30 beds. The turnoff is clearly signposted from the main road.

In the Serengeti National Park there are two large lodges, the Seronera Wildlife Lodge and Lobo Lodge. The former is centrally situated and the latter is located some 70 kilometres to the northeast. They have been built among granite outcroppings and offer impressive views of the grasslands. They have 150 beds, with full catering and *en suite* facilities. There is a swimming pool at Lobo Lodge. Bookings for each of the lodges can be arranged through Serengeti Safari Lodges Limited, PO Box 3100, Arusha, Tanzania.

There are four campsites at Seronera, one at Lobo, one at Moru Kopjes and one each at Naabi Hill Gate and at Kirawira. Some have pit toilets but none have water. Most are pleasantly located but visitors must always be aware that none of the camps is fenced and that potentially dangerous game, such as buffalo and lion, frequently passes through.

NGORONGORO WILDLIFE LODGE

This lodge is owned by the Tanzanian government and from the outside looks like a large, modern railway station. It is perched on the rim of the crater and offers magnificent views from all the rooms. The balcony overlooks the Lerai Forest. It has dining and bar facilities and 150 beds. The lounge also has extensive windows allowing for unhindered panoramas. Although guests may not wander beyond the grounds, the forest location allows for some good bird-watching. Marabou Storks roost in the trees behind the staff quarters, just below the entrance drive.

For more information about the Wildlife Lodge contact Tanzania Hotels Investment, PO Box 877, Arusha, Tanzania.

NGORONGORO CRATER LODGE

This is a much smaller lodge than the Ngorongoro Wildlife Lodge, and has a capacity of 60 beds, a central dining and bar building, a comfortable lounge, and separate wooden cottages and rooms scattered through the grounds. Plains zebra and buffalo, amongst other animals, frequently feed between the buildings. As is the case with all the lodges, guests have the choice of paying for bed and breakfast or full board. All prices are quoted in US dollars for foreign visitors.

For more information about the Crater Lodge contact Windsor International Hotels Ltd, PO Box 751, Arusha, Tanzania.

RHINO LODGE

Rhino Lodge is located in a beautiful patch of forest just off the main road. The lodge has a capacity of 46 beds, a communal lounge, bar and dining area. It is more reasonably priced than the other lodges.

For more information contact the Rhino Lodge, PO Box 792, Arusha, Tanzania.

NGORONGORO SOPA LODGE

This large lodge is perched on the eastern rim of the Ngorongoro Crater and can be reached by crossing the crater floor, or by following the southern rim road. It is within easy reach of both the Olmoti and Empakaai craters. There are 96 beds (the rooms have *en suite* facilities), a lounge and bar.

For more information contact Ngorongoro Sopa Lodge, PO Box 1823, Arusha, Tanzania.

NDUTU SAFARI LODGE

Bordering on the Serengeti National Park, the Ndutu Safari Lodge is situated in acacia woodland overlooking Lake Ndutu. It is the most isolated of all the lodges in the Ngorongoro Conservation Area. However, the access roads are clearly signposted from the main Ngorongoro/Seronera route. The lodge has a capacity of 70 beds, and each room has its own shower and toilet.

For more information contact Ndutu Safari Lodge, PO Box 6084, Arusha, Tanzania.

WHEN TO GO

The Ngorongoro Conservation Area is open throughout the year but during the rainy season (from November to May) movement may be restricted. Within the crater itself high densities of game are present all year round but on the plains the quantity of game is dictated by the availability of food and water. Even during the height of the dry season (from June to October) you can still expect to see a wide variety of resident mammal and bird species on the western plains. It is during the rains that many game species drop their young and it is also the best time to see migrant bird species. Each of the seasons has plenty to offer the visitor.

CURRENCY

Non-Tanzanian residents will be expected to pay park and lodge fees in foreign currency, usually US dollars, but food, alcohol, fuel and other purchases can be made in Tanzanian shillings. Currency should be changed at the state banks as they generally give the best rate. Do not change money on the street as it is illegal – police traps are common and the penalties severe. Most of the major credit cards, such as Visa and MasterCard, are accepted at the lodges but the majority of retail outlets insist on cash.

GETTING AROUND

As previously mentioned, there are numerous safari companies that take clients into the Ngorongoro Conservation Area, usually as part of a tour package. If you have no experience of African travel, an organized tour is highly recommended. Apart from the big operators there are several smaller, more personalized safari outfits available that cover Ngorongoro, Serengeti and Masai Mara.

If you are driving yourself, follow the established roads and tracks. Only if you have secured permission and are well equipped (preferably with two vehicles) should you head for such locales as the Gol mountains, Nasera Rock and the western Salei Plains. Most excursions from the main roads should be restricted to the dry season. The main, all-weather roads are in reasonable condition but corrugated in parts and flash floods can wash away the roads. If you intend exploring take sufficient fuel, water, food and spares, as a breakdown away from the principal routes could leave you stranded for several days. Permission to camp away from the designated sites must be obtained from the conservation area headquarters.

If you arrive on a motorbike or bicycle, or on foot, you will require permission to enter the conservation area and this is not always forthcoming. Hitchhikers have been known to enter the area, relying on those visitors with vehicles to take them into the crater and elsewhere, but entry is not guaranteed.

WHAT TO TAKE

The clothing you need depends on the time of year you intend to visit Ngorongoro. During the early part of the dry season (June and July) it can be very chilly at night, particularly in the eastern highlands, and evenings remain cool until about October. For dry-season evenings you will need a jersey and jacket but the days are generally mild. During the rainy season it is much warmer and frequently hot, particularly on the plains. At all times of the year you should wear a broad-brimmed hat and a sunscreen. All your clothing should be comfortable and cool – cotton is recommended

Take all your photographic film, spare batteries and cleaning materials; the latter are essential because of the fine dust that, if not removed, can ruin your equipment. If you are travelling independently ensure that you have adequate fuel supplies – petrol and diesel are available only at the conservation area headquarters. Fuel is also available at Seronera in the Serengeti and at Mto-wa-Mbu near Lake Manyara.

PHOTOGRAPHIC TIPS

The eager photographer will need a standard or wide-angle lens for scenic shots, and at least a 300-millimetre telephoto lens for game and bird photography. If you can afford it invest in at least a 400-millimetre lens, or a 200 millimetre lens with a good quality 2X converter. Most of your photographs will be taken from a vehicle, so a 'bean bag' will provide more stability than a tripod. We use two-kilogram bags of rice sown into cloths and placed over the open window.

Remember that early-morning and late-afternoon photography gives the best results. Midday light is harsh and produces flat and uninteresting photographs. Smoke and dust can be a hindrance to scenic shots in the dry season but it can also enhance your pictures if carefully planned. It is very important to keep your equipment as free of dust as possible, using plastic bags, air brushes and other cleaning devices. Exposure to grinding dust on only a few occasions can mean the end of expensive cameras and lenses.

GENERAL INFORMATION

Poaching is an ever-present problem in any conservation area, but the Ngorongoro Conservation Area has fared considerably better than most, primarily because the nomadic Maasai pastoralists are not generally meat-eaters. There is, however, some subsistence poaching, although the problem is much greater in the western corridor of Serengeti. In recent years a more worrying trend has taken hold, namely commercial meat poaching. Should you encounter any poachers, or freshly butchered carcasses, report your observations as soon as possible to the area headquarters, one of the lodges, or a ranger post on your route. Never try to apprehend poachers as they are armed and will usually not hesitate to shoot.

During the dry season the visitor will encounter grass fires, either within Ngorongoro, Serengeti or fringing areas, and they could have one of several origins. The Maasai pastoralists light fires just prior to the rains in order to encourage the growth of grass for their cattle, but many game species benefit from this. There are also the fires started by cattle rustlers and poachers in an attempt to

ABOVE: *There are numerous private safari companies offering personalized trips and camps in Ngorongoro and Serengeti.*

hide their tracks. These are wildfires that usually run out of control, and in an effort to limit the damage resulting from these burns the authorities in both conservation areas occasionally conduct controlled burning.

When leaving your vehicle in the conservation area it is important to follow a few simple rules which are really just plain common sense. Never get out of your vehicle in dense undergrowth, as the bush could also be harbouring such species as lion or leopard. Even in seemingly open terrain with minimal cover, it is essential that you check carefully that you are 'alone', as even a lion can blend superbly into the foreground. Do not climb out of your vehicle close to any game species as you will only disturb them and they will move away.

Within the Ngorongoro Conservation Area you should never wander too far from your vehicle, as it is very easy to become quite disorientated and consequently lost. Walking should not be contemplated unless you are accompanied by a competent guide. Although this applies throughout the area, it is extremely important in the hill country, the Gol mountains and Olduvai.

MEDICAL INFORMATION

The whole of northern Tanzania is a malaria area and you should ensure that you are on a suitable course of anti-malaria tablets. Consult your doctor for the most suitable prophylactic before entering East Africa. You should also sleep under a mosquito net, use suitable insect repellents and wear long-sleeved shirts and trousers after sunset. Tsetse flies are known to be present in the lower lying woodland areas towards Serengeti.

Only drink bottled water, or water that you have boiled or treated with chlorine tablets – do not be tempted to drink stream water, or water directly from taps. Beware of ice cubes and ice cream, salads and unpeeled fruits, as they are potential disease carriers.

Check with your doctor which immunizations are required for Tanzania; at the time of writing only yellow fever was essential but your physician may recommend additional vaccinations such as polio and typhoid.

If you are on medication you should carry all your requirements for the duration of your trip. It is also advisable to carry a basic first-aid kit containing such basics as aspirin, plasters and an antiseptic, as medical facilities are limited. Although the chances of serious illness or injury are small, it is worthwhile taking out a reliable medical insurance that includes repatriation in an emergency.

FURTHER READING

Blundell, M. *Wild Flowers of East Africa.* Collins, London, 1987.

Briggs, P. *Guide to Tanzania.* Bradt Publications, Buckinghamshire, 1993.

Bygott, D. *Ngorongoro Conservation Area.* D. Bygott & Co., Karatu, 1992.

Dorst, J. and Dandelot, P. *A Field Guide to the Larger Mammals of Africa.* Collins, London, 1970.

Fosbrooke, H. *Ngorongoro: The Eighth Wonder.* Andre Deutsch, 1972.

Grzimek, B. and Grzimek, M. *Serengeti Shall Not Die.* Dutton, New York, 1960.

Leakey, M. *Olduvai Gorge.* Collins, London, 1979.

MacLean, G. *Roberts' Birds of Southern Africa.* John Voelcker Fund, South Africa, 1993.

Sinclair, A. and Norton-Griffiths, M. (Editors). *Serengeti: Dynamics of an Ecosystem.* University of Chicago Press, Chicago, 1979.

Stuart, C. and Stuart, T. *Southern, Central and East African Mammals: a Photographic Guide.* Struik Publishers, Cape Town, 1993.

Van Lawick, H. *Predators and Prey.* Random House, New York, 1986.

Williams, J.G. and Arlott, N. *A Field Guide to the Birds of East Africa.* Collins, London, 1992.

Struik Publishers (Pty) Ltd
(a member of The Struik Publishing Group (Pty) Ltd)
Cornelis Struik House, 80 McKenzie Street
Cape Town 8001

Reg. No. 54/00965/07

Published edition 1995 © Struik Publishers

*Text © **Chris and Tilde Stuart***
Photographs © individual photographers and/or their agents as follows:

Daryl and Sharna Balfour: *pp. 3, 13, 15 (top left), 17 (top and bottom),*
18, 19, 20 (bottom left), 22 (top right and top left), 23 (top and right),
24, 27, 28 (bottom), 30 (top), 35 (top), 41 (bottom left), 45.
Andrew Bannister [SIL]: *p. 20 (bottom right).*
Anthony Bannister [ABPL]: *pp. 42 (bottom left), 43 (bottom).*
Alan Binks [ABPL]: *pp. 9, 10 (left), 34 (bottom), 38.*
Peter Blackwell: *title page, pp. 8 (bottom), 20 (bottom centre), 25 (top left).*
Vanessa Burger: *pp. 11 (bottom), 29 (bottom), 31 (top and bottom).*
Camerapix: *pp. 4, 6, 12 (bottom), 36, 37, 42 (bottom right), 44.*
Roger de la Harpe: *p. 20 (top left).*
Nigel Dennis: *p. 15 (bottom).*
Clem Haagner [ABPL]: *p. 20 (top right).*
Beverly Joubert [ABPL]: *pp. 33, 43 (top).*
Mitch Reardon: *pp. 2, 14, 16 (left), 22 (bottom right and bottom left), 25 (top right), 32,*
40 (top, bottom left and bottom right).
Dave Richards: *pp. 7, 11 (top), 21 (left and right), 25 (bottom), 28 (top), 39, 41 (top).*
Brendan Ryan [ABPL]: *pp. 10 (right), 41 (bottom right).*
Anup Shah [ABPL]: *p. 12 (top).*
David Steele [Photo Access]: *front cover, pp. 29 (top), 30 (bottom), 34 (top), 35 (bottom), 47.*
Chris and Tilde Stuart: *p. 8 (top).*
Gavin Thomson [ABPL]: *pp. 16 (right), 23 (bottom), 26, 42 (top), back cover.*
Tom van den Berg: *p. 15 (top right).*
(SIL: Struik Image Library. ABPL: ABPL Photo Library)

Managing editor: Mariëlle Renssen
Editor: Christine Riley
Designer: Julie Farquhar
Reproduction by Unifoto (Pty) Ltd, Cape Town
Printed and bound by Kyodo Printing Co (Pte) Ltd, Singapore

ISBN 1 86825 749 5

Acknowledgements
The authors wish to warmly thank Pat and Mona Frere for their
tolerance and hospitality while they were writing this guide.